HARPENDEN

THE POSTCARD COLLECTION

JOHN COOPER

AMBERLEY

To my dear sister Anne, Phil, Annette, Ruby and Oliver.

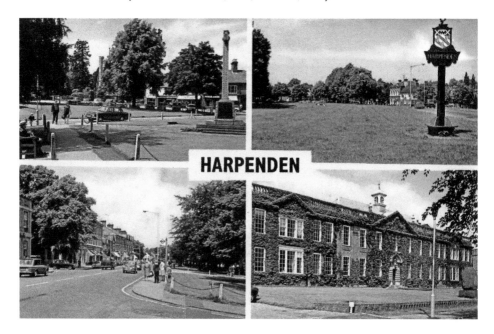

Also by John Cooper:
A Harpenden Childhood Remembered: Growing up in the 1940s & '50s
Making Ends Meet: A Working Life Remembered
A Postcard From Harpenden: A Nostalgic Glimpse of the
Village Then and Now
Watford Through Time
A Postcard From Watford
Harpenden Through Time
Rickmansworth, Croxley Green & Chorleywood Through Time
Hertfordshire's Historic Inland Waterway: Batchworth to Berkhamsted
Watford History Tour

First published 2016

Amberley Publishing
The Hill, Stroud, Gloucestershire, GL5 4EP
www.amberley-books.com

Copyright © John Cooper, 2016

The right of John Cooper to be identified as the
Author of this work has been asserted in accordance with
the Copyrights, Designs and Patents Act 1988.

ISBN 978 1 4456 5918 3 (print)
ISBN 978 1 4456 5919 0 (ebook)

British Library Cataloguing in Publication Data.
A catalogue record for this book is available from the
British Library.

Typesetting by Amberley Publishing.
Printed in Great Britain.

CONTENTS

INTRODUCTION

Situated approximately midway between Luton and St Albans on the busy A1081 is the picturesque small country town of Harpenden in Hertfordshire, still known locally as 'the village' by the older residents.

Following the arrival of the Midland Railway in 1868, providing a direct link with the capital, and with farmland being gradually released for housing, Harpenden's transformation from an agricultural village to the bustling commuter town of today had begun. In accompaniment with these changes were the ever-present photographers, dedicated local men such as Daniel Barton Skillman, Oliver Harvey and Cecil Hallam who, with their cameras, primitive when compared to today's sophisticated equipment, braved the elements throughout the four seasons to capture mostly local views and events and to provide us with a lasting pictorial legacy of Harpenden's heritage. Many fine pictures were also taken by photographic businesses such as A. E. Nicholls from Luton and, from further afield, Lilywhite Ltd of Halifax.

A by-product from the countless images that were taken was the picture postcard, which from the very beginning grew in popularity, so much so that the period between about 1900 and 1918 was universally accepted as the 'Golden Age' of the postcard. It was a fast and inexpensive form of communication where a message sent to a loved one in the morning could very often be delivered to the recipient by the afternoon post a few hours later. In the Edwardian era, it was the email of its day. Although the telephone developed by Alexander Graham Bell in the mid-1870s was available, it was not in general use then to the extent that it is now, and certainly not among the less affluent members of society.

Although many postcards were unfortunately destroyed once they had been read, countless more were lovingly preserved in albums, thus spawning a popular hobby that still thrives to this day. With subject matter too numerous to mention here, it is the topographical views of our villages and towns, frozen in time, that provides us with so much visual information of our past.

As we journey around the village and peruse the fascinating images of yesteryear, we witness the annual horse races on the Common which were held in May of each year from 1848 until the outbreak of the First World War in 1914. This popular event attracted throngs of people from far and wide, all intent on placing a small wager on their favourite horse. We pause for a while at the Silver Cup Pond, a magnet to generations of children who flocked to

the water each summer, to either paddle or to sail a toy yacht. It was a sad day when the pond was eventually filled in after being deemed a potential health hazard.

Of all the picturesque views in Harpenden, probably the beautiful panorama of the common was the most photographed, with vistas of the wide boulevard that is the High Street a close second. It was in the High Street that the scenic Cock Pond was situated, where cattle and horses drank their fill. Just behind the pond was the blacksmith's forge of H. Lines which had been built in 1820 but closed in 1957 after being worked by three generations of the Lines family. Older residents will remember Mr Lines shoeing a horse or pumping up the fire with his bellows, as well as recalling the smell of the horses and the red-hot metal as a shoe was fitted to a horse's hoof.

Although no longer the quiet and tranquil village that it used to be, Harpenden still exudes a certain charm of its own and is undeniably a lovely place to live, work or visit, as this nostalgic glimpse into the past using old picture postcards will surely testify.

John Cooper

Acknowledgements

I am extremely grateful to the following for their kind assistance and for their helpful advice and comments: Liz Allsopp, Rothamsted Research; Christine Barrow, the Pilkington Family Trust; Les Casey, the Harpenden & District Local History Society; Maggie Johnston, Rothamsted Research; Geoff Newman, Harpenden Cricket Club; Rosemary Ross, the Harpenden & District Local History Society; Julia Skinner, The Francis Frith Collection; John Wassell, the Harpenden & District Local History Society and Trevor Wolford, Judge Sampson Ltd.

Special thanks are extended to my wife Betty for her constant support, encouragement and invaluable input, to my son Mark for his continuous IT support and to my publishers, Amberley Publishing, for their kind assistance in producing this publication.

Every endeavour has been made to contact all copyright holders, and any errors that have occurred are inadvertent. Anyone who has not been contacted is invited to write to the publishers, so that a full acknowledgement may be made in any subsequent edition of this book.

CHAPTER 1
ACROSS THE COMMON – GATEWAY TO HARPENDEN

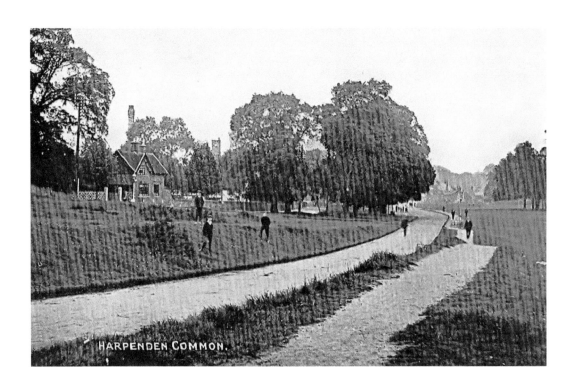

HARPENDEN COMMON.

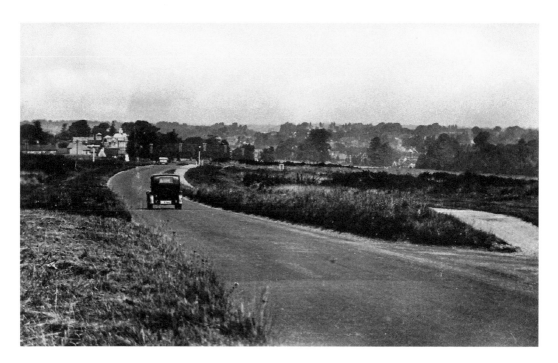

Approaching Harpenden

These two charming real photograph postcard images, taken in the 1930s at the top of the common, depict the scenic panorama of Harpenden, a picturesque Hertfordshire village lying in the valley below. What is now the busy A1081 from St Albans was, over eighty years ago, little more than a quiet country road. Today, this lovely view is almost obliterated by the growth of trees, bushes and high shrubs that have gradually matured during the intervening years.

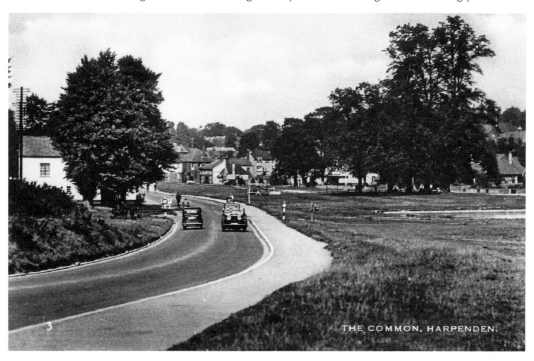

THE COMMON, HARPENDEN.

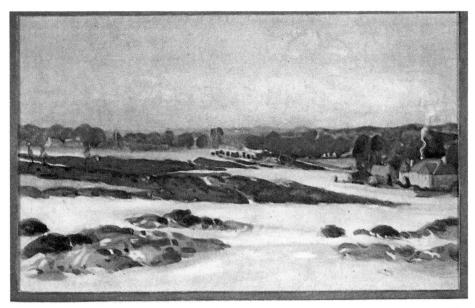

Harpenden Common, Herts. (looking North). Christmas Greetings. *Sketched by E. Heasman, 1912.*

Sketches of the Common

These delightful coloured sketches of the common were produced by renowned local artist Alfred Ernest Heasman, in 1912 and 1914 respectively. Born on 15 February 1874 in Lindfield, Sussex, Heasman's first job was as a draughtsman for the stained-glass artist Charles Kempe. Following his studies at the Slade School between 1898 and 1901, he later joined the firm of Herbert Bryans as head draughtsman before eventually leaving to follow his own design and painting pursuits. Ernest Heasman lived in the village for twenty-two years, sketching many attractive views of the locality, until his death on 26 July 1927 aged fifty-three.

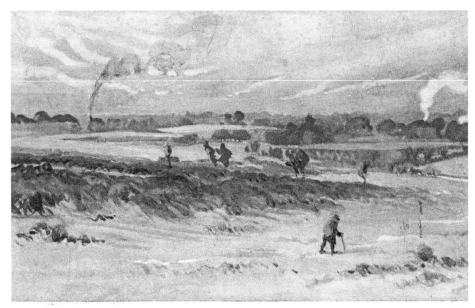

Harpenden Common, Herts. (looking North). *Sketched by E. Heasman, 1914.*

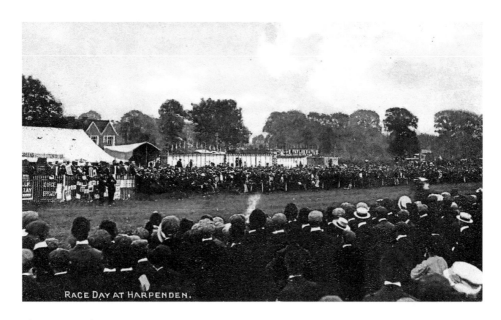

RACE DAY AT HARPENDEN.

The Harpenden Horse Races

A popular annual event, the Harpenden Horse Races were held on the common in May of each year during the week before the Derby, from 1848 until the outbreak of the First World War in 1914. The races attracted large crowds from far and wide including London. This meant that a strong police presence was necessary to control the racegoers and to keep a vigilant watch for the many undesirables such as pickpockets, card sharpers and other ruffians who came in search of easy pickings. The course started on the common, near to what is now the clubhouse for Harpenden Common Golf Club, and crossed Walkers Road before sweeping into the country beyond Cross Lane, over the Childwickbury Estate, turning near Ayres End Lane prior to returning back along the common. At the end of each meeting, the grandstand was dismantled and stored at Watler's Farm in Queens Road.

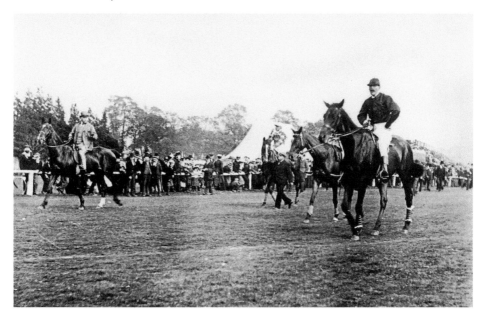

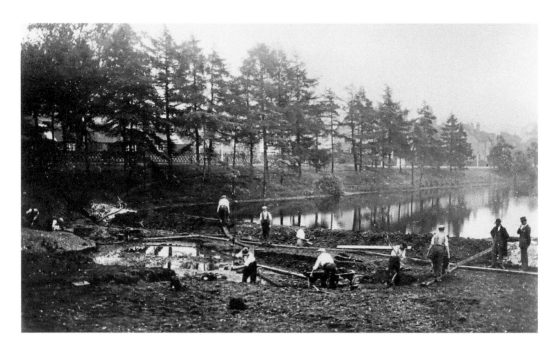

The Southdown Ponds

Following a review of its drainage system in 1928, the Urban District Council decided to fill in the Cock Pond in the High Street and pipe the small stream that flowed along Lower High Street underground to the gravel pits on the common, adjacent to Southdown Road. To achieve this, it was necessary to improve the pits, which had originally been dug out in the 1870s, to form three ponds at descending levels to carry the storm and surface water from the village. The work was carried out in 1929. Today, this lovely area, sometimes known as 'Little Switzerland', remains a pleasant place to stroll and linger awhile. (*Below*: Courtesy of the Francis Frith Collection)

The Common, Harpenden

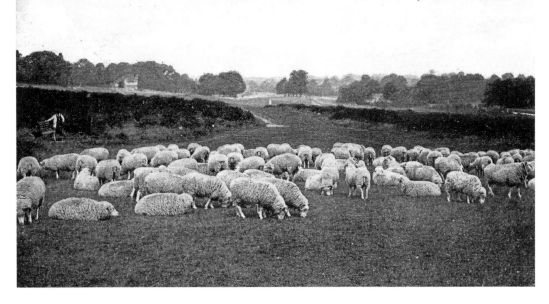

Sheep Grazing

A familiar sight in the early part of the twentieth century were the flocks of sheep that regularly grazed on the common. A well-known local character of the time was 'Shep' Arnold, a shepherd who lived at Batford Mill, who daily herded his flock from Mackerye End Farm to the common by way of Crabtree Lane. These two rustic images from those far-off days depict a scene that has long since vanished. The writer of the above card, which was sent in 1907, has drawn the recipient's attention to their house among the trees on the far side of the common by marking the spot with an 'X'.

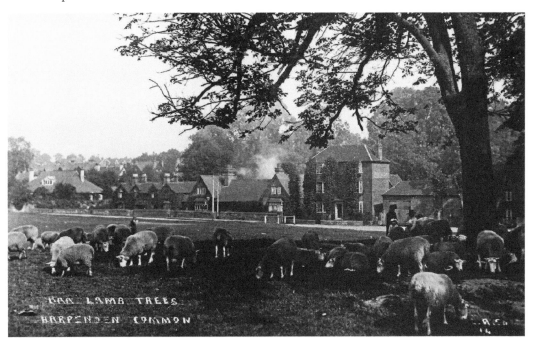

The Common, Harpenden.

The Silver Cup Inn

These two idyllic similar views show the historic Silver Cup public house, a lovely old inn built in 1838 by the Wheathampstead brewer, John House. It is situated on what is now the A1081 from St Albans on the beautiful Harpenden Common, a short distance from the village centre. A year after the pub opened, a 'Friendly Society' regularly met in the hostelry where, if they had paid their quarterly subscriptions on time, members could then request a free pint of beer. Well-known local photographer, Daniel Barton Skillman, captured the top image, which was posted on 28 May 1907, and also features the popular Silver Cup Pond. The real photograph picture postcard below was taken some time later by Cecil Hallam, another Harpenden photographer.

THE COMMON
HARPENDEN

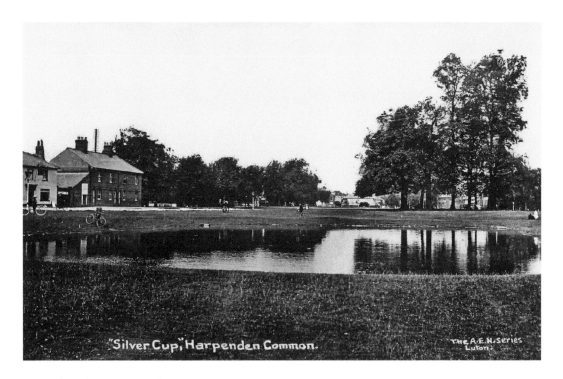

"Silver Cup," Harpenden Common.

The A.E.N. Series
Luton.

The Silver Cup Pond

The often-photographed Silver Cup Pond on the common provided many a happy, and in all probability, a very wet hour or so spent either paddling or sailing a toy yacht to generations of youngsters who flocked to the water each summer – as can be seen in the early real photo card below. In 1899, Sir John Bennet Lawes of Rothamsted Manor had the pond concreted from its natural state in order to provide a safer and more permanent environment for the countless children who used it. It was a sad day when, in 1970, the pond was filled in and grassed over, as it was deemed to be a potential health risk. It was the end of an era.

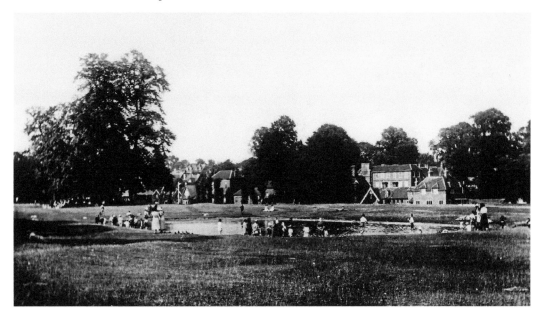

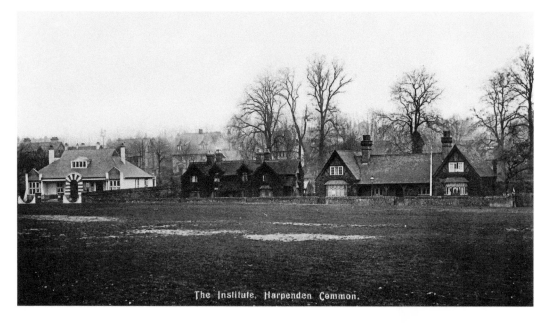

The Institute, Harpenden Common.

The Institute

The Institute in Southdown Road, or Wheathampstead Road as it was then called, opened on 10 January 1887 as the new premises for the Harpenden Lecture Institute and Reading Club. For many years, the Institute became the focus of social life in the village, where recreational games such as chess, draughts and bagatelle were provided, although playing for money was strictly prohibited. Following its eventual closure in March 1912, the building was subsequently utilised as a military hospital for several months of the First World War and used by the Territorials who were stationed in Harpenden, before moving in 1915 to larger accommodation in Milton Road. In 1933, the premises were sold and purchased by the Religious Society of Friends, the Quakers, to hold their meetings, and is currently the Friends' Meeting House.

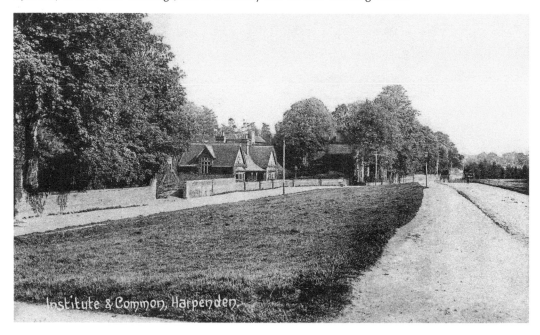

Institute & Common, Harpenden.

Under the Baa-Lamb Trees, Harpenden Common, Herts. *Sketched by E. Heasman 1914.*

The Baa-Lamb Trees

Ernest Heasman's charming coloured sketch of 1914 depicts a cluster of trees on the common known as the Baa-Lamb trees, a familiar local landmark for generations. There is some speculation as to the origin of the name. One suggestion is that it derived from the days when sheep were allowed to graze on the common, although a more plausible explanation could be that as there was once a house called Balaams on the site of the trees in 1652 – the name eventually became corrupted to Baa-Lamb. The bottom photograph, taken around 1937, is an excellent example of the common looking southwards, with the Silver Cup Pond featured in the centre of the picture while a cricket match can be seen being played in the background.

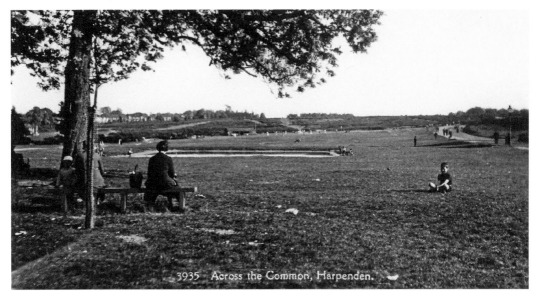

3935 Across the Common, Harpenden.

15

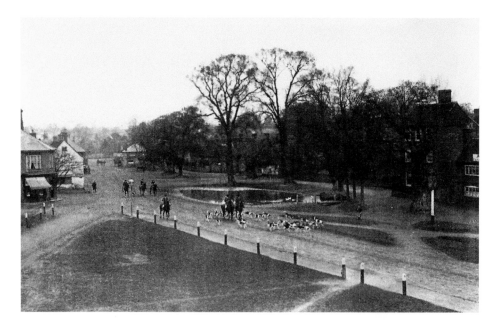

The Hertfordshire Hunt

The above image shows the huntsmen with their hounds riding through the village circa 1905 for a meet of the Hertfordshire Hunt on the common below. The kennels for the hounds were originally based at Kinsbourne Green, but with the outbreak of the Second World War they were transferred to Houghton Regis in Bedfordshire. One of the favourite meets of the hunting calendar was on Boxing Day morning, where the huntsmen, resplendent in their scarlet coats and white breeches and the ladies looking elegant sitting side-saddle, would enjoy the traditional pre-hunt 'stirrup cup' drink before setting off to the sound of the horn in the crisp, cold air, the baying hounds eager to pick up the scent of the fox.

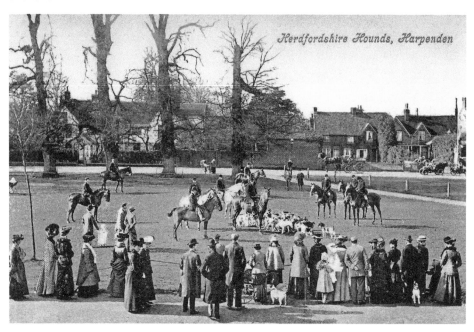

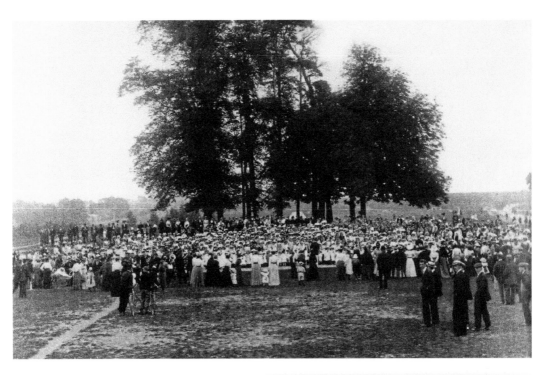

The Coronation of Edward VII

Following the death of Queen Victoria on 22 January 1901, her son Edward VII succeeded to the throne, with his coronation arranged for 26 June 1902. As with towns and villages throughout the country, festivities were held in Harpenden to celebrate this spectacular event. However, just forty-eight hours before the big day, the king was taken ill with an abdominal abscess that required immediate surgery. Although the coronation was rescheduled to 9 August, it was decided that the planned arrangements for 9 July would still go ahead. Throngs of people gathered around the Baa-Lamb trees on the common, above, where a children's fete and sports with prizes had been organised followed by a sumptuous tea. Each child was then presented with a decorated china mug to commemorate the occasion. The king sadly died on 6 May 1910.

his Late Majesty King Edward VII.
1841–1910.

17

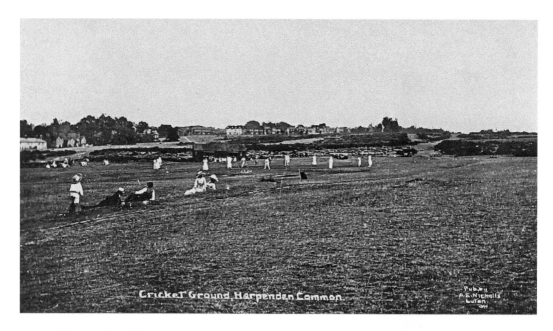

Harpenden Cricket Club

During the warm summer months of 1914, thoughts of the impending conflict were far from these spectators' minds as they sat watching a sociable and relaxing Sunday afternoon game of village cricket in these quintessential images taken on the common. Harpenden Cricket Club was formed in 1863 when John Bennet Lawes, as lord of the manor and the club's first president, consented to the use of his 'wasteland' for cricket matches. However, the first mention of cricket on the common was over thirty years earlier when a game was played between four right-handed and four left-handed players. Unfortunately, the outcome of this 'novel match' was not recorded, but the odds were 6–4 on the left-handed batsmen. Today, with a beautiful amphitheatre of a ground and a superb pavilion, the club has expanded to become one of the top cricket clubs in Hertfordshire.

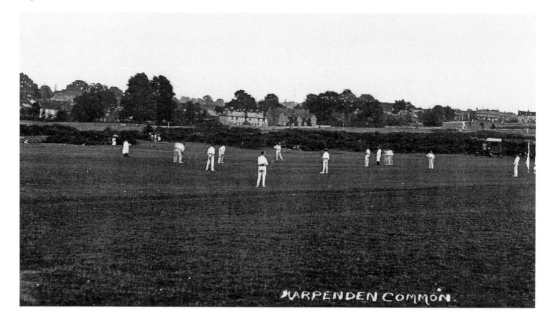

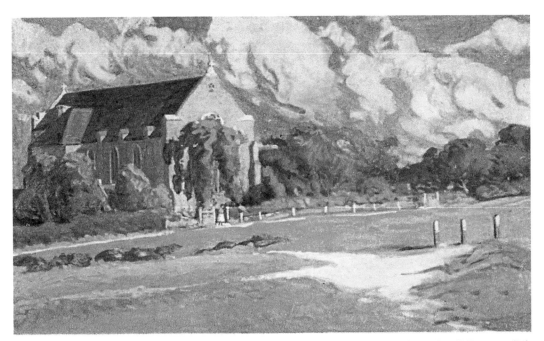

St. John's Church. Harpenden, Herts.

Sketched by E. Heasman, 1914.

St John's Church

These two unused postcards show St John's Church located on the edge of Harpenden Common in South Harpenden. Following the devastating fire of 1905, when the original church was destroyed, land for the new simply designed building by local architect, Mr F. C. Eden was given by Sir Charles Lawes Wittewronge, son of the late Sir John Bennet Lawes. The land was part of an old orchard with one ancient tree still remaining in the vicarage garden. The church was consecrated on 2 March 1908, with the top image showing another of Ernest Heasman's delightful sketches. In 2008, the church marked its centenary with a varied programme of celebrations and events throughout the year.

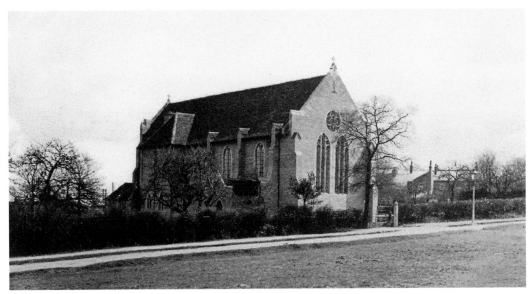

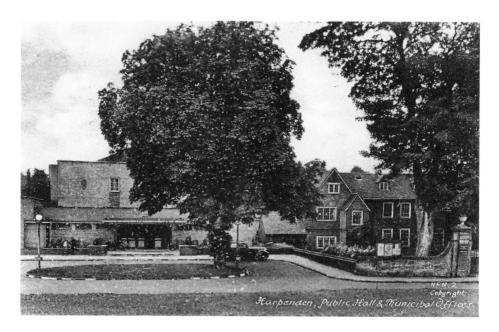

The Public Hall

The Public Hall, which first opened its doors in 1938, has been a popular venue for nearly eighty years, not only for the local community but further afield as well. In the 1940s and 1950s, the young people of the day would regularly meet for the Saturday night dances where they could jitterbug, waltz, quickstep and jive to the strains of George Mason and his band or the well-known Geoff Stokes band. The annual Scout Gang Show was also another eagerly awaited event. Today, the building is known as the Harpenden Public Halls, the Eric Morecombe Hall, named after the famous comedian who lived in the village until his untimely death in 1984, and the smaller Southdown Room. (*Above*: Reproduced from an old F. Frith & Co. Postcard)

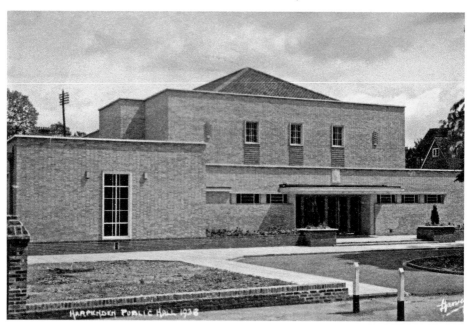

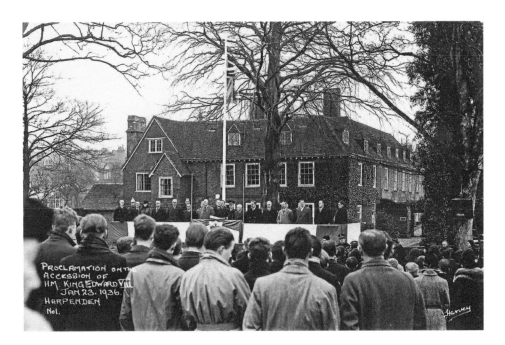

Harpenden Hall

Built in the sixteenth century, Harpenden Hall has seen many events in its long history, including the image above that captures the Proclamation on the Accession of Edward VIII on 23 January 1936. The Hall was, at one time, a private lunatic asylum, a girls' boarding school and, more recently, the offices of the Urban District Council. From 1924 until 1931, the building was used by St Dominic's Convent School until their move the short distance down Southdown Road to their new premises in the Welcombe, once the home of Henry Tylston Hodgson, a local benefactor.

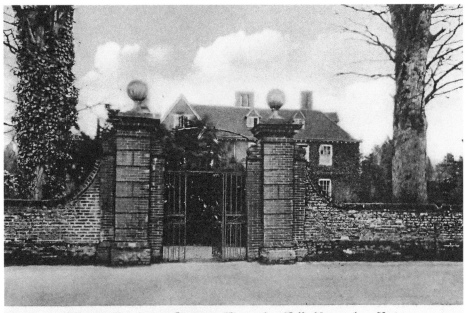

Gateway. Dominican Convent. Harpenden Hall. Harpenden. Herts.

CHAPTER 2

HATCHING GREEN
AND ROTHAMSTED

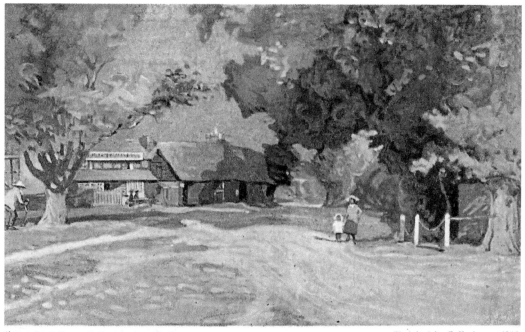

"Hatching Green," Harpenden, Herts. *Sketched by E. Heasman, 1914.*

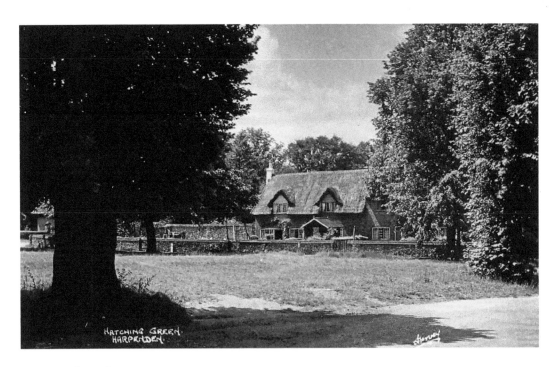

Hatching Green

These charming real photograph images depict the small hamlet of Hatching Green, a short distance from the centre of Harpenden. The postally unused card below is of the seventeenth-century Grade II-listed White Horse public house, a popular venue situated on what is now the B487 to Redbourn. Just out of camera shot on the left-hand side of the top picture is Manor Drive, once the main entrance to Rothamsted Manor, the birthplace of John Bennet Lawes, the founder of Rothamsted Experimental Station.

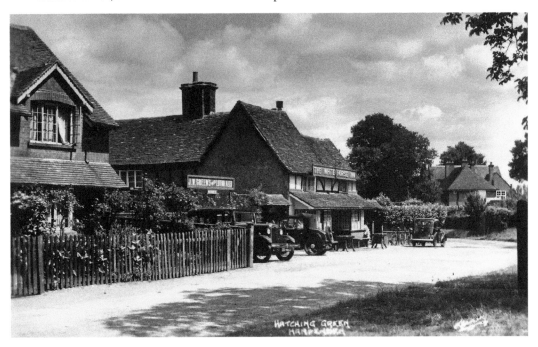

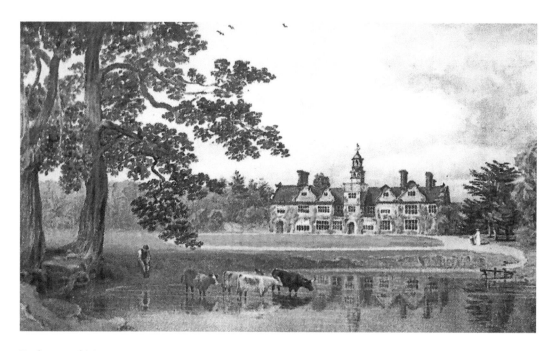

Rothamsted Manor

The lovely rural scene above shows Rothamsted Manor in 1892, and is of a watercolour painted by Lady Caroline Lawes, wife of Sir John Bennet Lawes. The manor was bought from Edward Bardolph in 1623 by Anne, the widowed mother of John Wittewronge (1618–93), later the 1st Baronet and the first Wittewronge to live at the manor. Although much of the exterior dates from the seventeenth century, the framework of the entrance hall is believed to have originated in the late thirteenth century. (*Above*: Courtesy of Rothamsted Research Ltd)

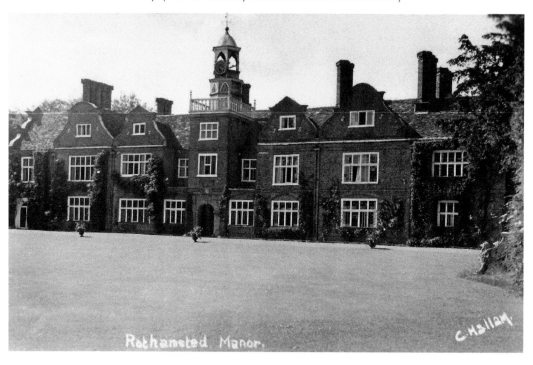

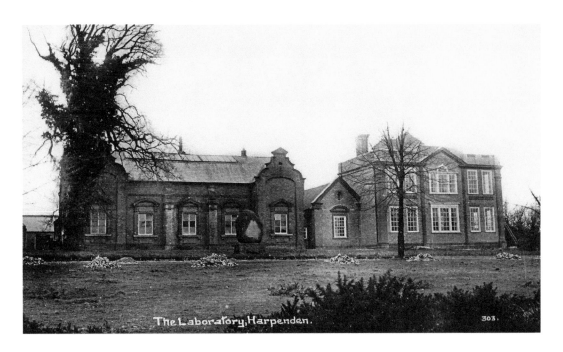

The Laboratory, Harpenden. 303.

Rothamsted Experimental Station

John Bennet Lawes, who founded Rothamsted Experimental Station in 1843, was born at Rothamsted Manor on 28 December 1814. As a young man, he became interested in the effects of fertilisers on crop growth and, in 1843, together with Dr Joseph Gilbert, started a series of field experiments to develop and establish the principles of crop nutrition. The above postcard shows the old testimonial building that was built in 1855 by public subscription of farmers nationwide and presented to Lawes and Gilbert in appreciation of the benefits their experiments were bringing to agriculture. The Russell building below was a purpose-made laboratory constructed in 1917 to replace the testimonial building. Centrally featured on both pictures is the Shap granite monument that was erected in 1893 to commemorate fifty years of research.

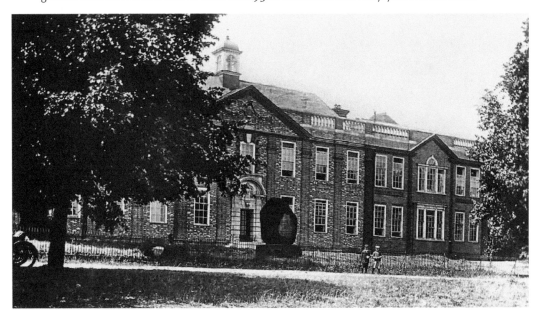

25

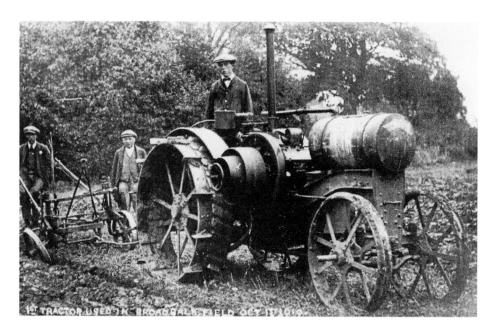

Broadbalk Field

The above image shows the first tractor that was used in the Broadbalk field on 1 October 1919. Initially, it was not very popular with the older farm workers, who viewed it as a 'new-fangled contraption'. The Broadbalk experiment was started by John Bennet Lawes and Dr Joseph Gilbert in 1843 where different organic manures and inorganic fertilisers were tested to see what effect they had on the yield of winter wheat. The experiment continues to this day. A short distance from Rothamsted is a picturesque row of sixteen terraced cottages on West Common as can be seen below, known as Pimlico Place, which were built in 1822 by the Benefit and Annuitant Society. At one time there used to be a public house called the Woodman's Arms and a bakery there, although these had gone by the early 1920s. (*Below*: Courtesy of the Francis Frith Collection)

CHAPTER 3
LEYTON ROAD
TO CHURCH GREEN

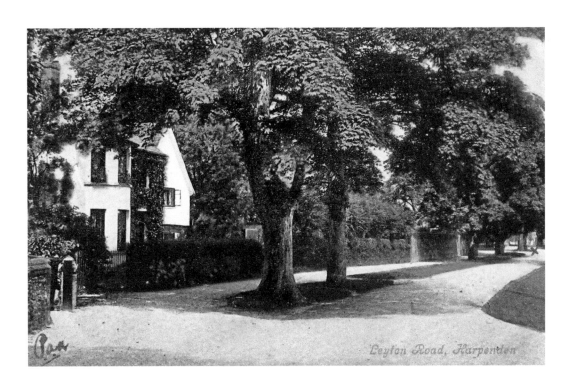

Leyton Road, Harpenden

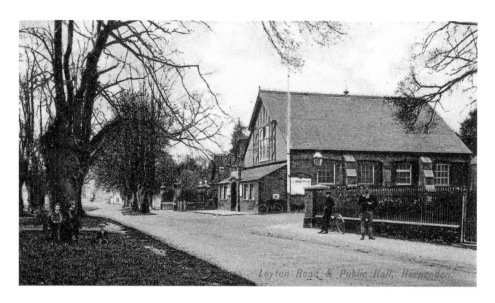

Park Hall

This historic building with its distinctive facade was constructed in 1850 by John Bennet Lawes as the British School, the first local school to provide education for the children of the local working classes. Following the school's move in 1897 to new larger premises in Victoria Road, the old site in Leyton Road was taken over a year later by the newly formed Harpenden Urban District Council for their offices and Public Hall, remaining there until 1931 when they transferred across the common to Harpenden Hall. Today, a new building to the rear of what is now Park Hall houses the town hall offices, while Park Hall continues to be used for community activities. The bottom picture depicts the iconic Harpenden sign on the right, which was designed by local artist Ernest Hasseldine, a member of the Harpenden Preservation Society. In 1937, the sign was presented to Harpenden by the society to commemorate the coronation of their majesties George VI and Queen Elizabeth on 12 May of that year.

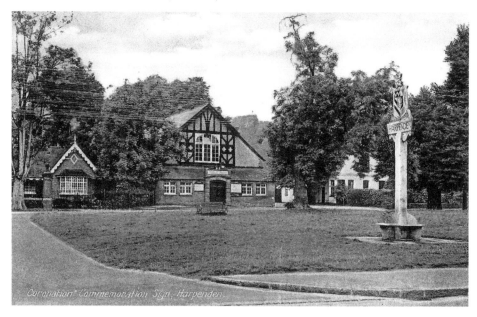

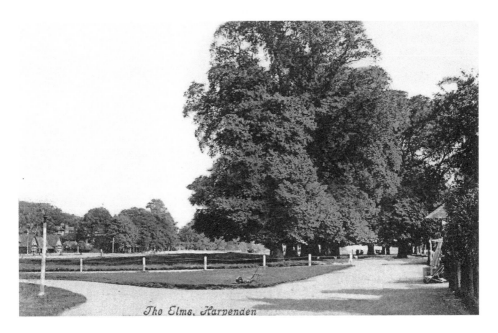

The Elms, Harpenden

Leyton Road

An early postcard dated 17 September 1904 above shows a peaceful summer's day viewed from Leyton Road towards the common, although the elms, as with those in other parts of central Harpenden, have long since been taken down due to Dutch elm disease. Just out of camera shot to the right further up the road is the entrance and gates to Rothamsted Park, as seen in the real photo card postally used on 15 August 1921. The park comprises a beautiful 56-acre area that was once part of the Rothamsted estate until it was purchased by the Urban District Council in 1938 as a place of relaxation and to provide sporting facilities. Today, the park is the location for the annual Harpenden Lions Highland Gathering, one of the largest Highland Games events outside Scotland.

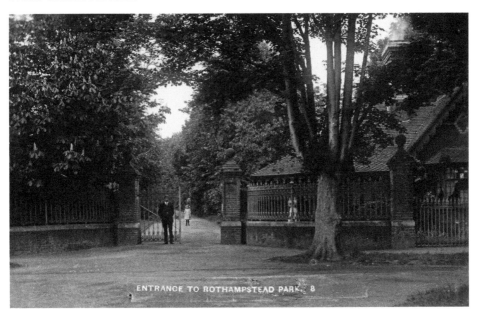

ENTRANCE TO ROTHAMPSTEAD PARK. 8

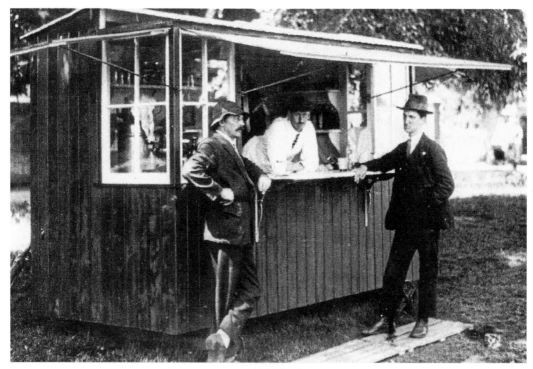

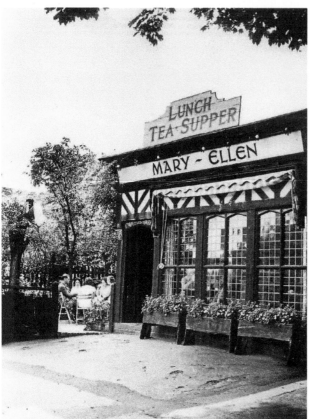

Tea Time

During the 1930s, there were two popular but very different catering establishments located a short distance from each other. Harry Bennett's coffee stall, which stood next to the Silver Cup cottages on the common, served the basic needs of passing motorists and lorry drivers, while Mary-Ellen's tea rooms in Leyton Road, which opened in 1932, tended to be more genteel, offering tea, scones and delicious homemade cakes to its many customers, all prepared by the proprietor, Miss Helen Finnie. By the early 1960s, Harry Bennett had ceased trading and Miss Finnie, originally from Scotland, retired in 1968. The premises were then rebuilt, opening in June 1972 as the Inn on the Green.

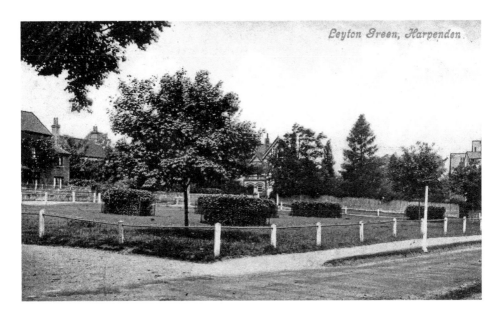

Leyton Green

Further along Leyton Road is an attractive open space called Leyton Green, as depicted above in a card postmark dated 4 September 1908. It was here in 1939, just before the outbreak of the Second World War, that two air-raid shelters were constructed below ground, each with a capacity for about 100 people. On 14 May 1913, Harpenden's first cinema, the White Palace, opened for business, occupying a position on the corner of Amenbury Lane at the junction with Leyton Road and closing in 1933 when the nearby Regent Cinema opened. A short distance from the green, a disaster occurred on 21 February 1916 that was known as 'The Great Fire at Harpenden' when the Heathfield Works, the premises of Abbott, Anderson and Abbott, caught fire, completely gutting the building and destroying the stock of waterproof oilskin clothing. Despite this massive setback, partial production recommenced two weeks later at temporary accommodation in Southdown.

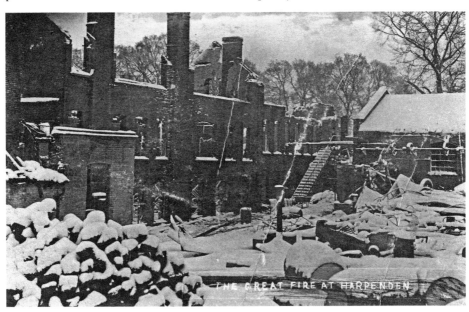

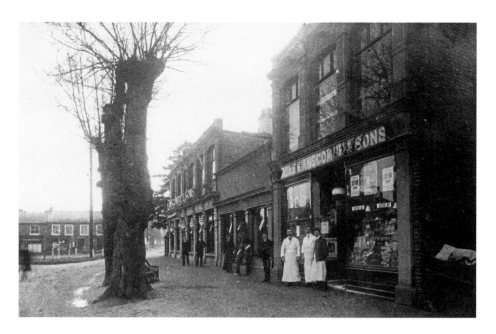

Anscombe's

Some of the staff of Anscombe's, at one time Harpenden's most prestigious retail outlet, can be seen posing for the photographer outside the shop in Leyton Road, as featured in this card postmarked 25 February 1906. The shop, which was founded in 1855 by Allen Anscombe, started trading in premises at the bottom of Thompson's Close before the business transferred to Wellington House in 1874. The shop prospered and, over the years, extended along Leyton Road selling a variety of goods including linen, hosiery, menswear, haberdashery and furniture. Anscombe's closed in 1982 and a Waitrose supermarket now occupies the site. The image below shows Harpenden Fire Brigade proudly displaying their gleaming appliance outside the decorated frontage of Anscombe's on the occasion of George VI's coronation on 12 May 1937.

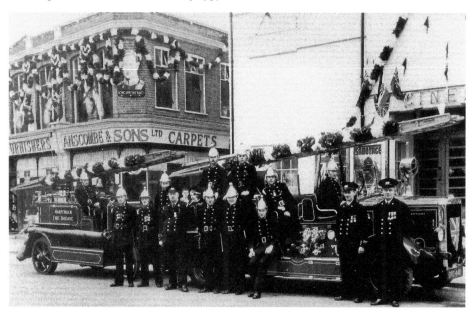

Wesleyan Chapel. Harpenden.

The Regent Cinema

Following the closure of the White Palace cinema (later renamed the Victoria Theatre) in 1933, the owner, Margaret Howard, acquired a recently vacated chapel in Leyton Road and converted it into a 410-seater cinema complete with a balcony. After a makeover with a new white frontage and multicolour neon lighting, the Regent opened its doors with an all British programme on 26 May 1933. By 1959, the Regent, by this time renamed as the State, closed with its final performance on 19 September. The building was then purchased by Anscombe's who altered the premises for use as a furniture showroom, before the site was eventually redeveloped into a supermarket.

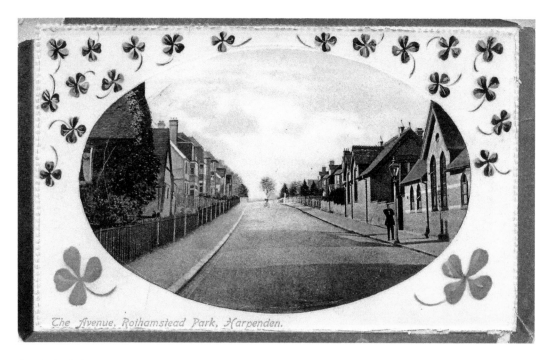

The Avenue, Rothamstead Park, Harpenden.

Batchelor's Row

Captured in the middle of a harsh winter, the snowy postcard image below, taken by local photographer Oliver G. Harvey, features a row of sixteenth-century cottages fronting Church Green. These were at one time or another during the 1920s and 1930s, occupied by the surgery of Doctors Maclean, Fraser and Ross, Miss Morgan, the headmistress of the nearby Church Infant School, and George William Curl, the parish clerk and sexton. Despite much local opposition, the cottages were demolished in the late 1950s to make way for a parade of shops and Harpenden's first supermarket. The top picture shows Rothamsted Avenue, a quiet residential road leading from Church Green, with part of the National School just visible on the right.

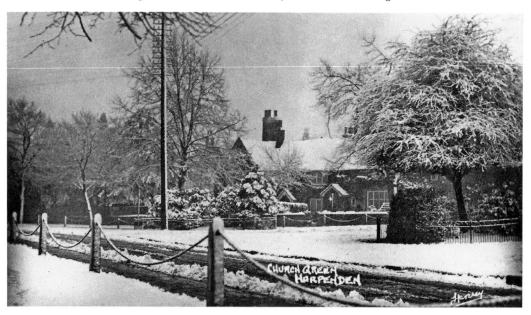

CHURCH GREEN
HARPENDEN

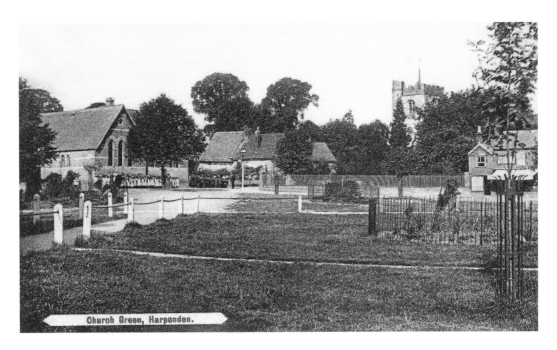

Church Green, Harpenden.

The National School

These two delightful unused cards show part of Church Green, with the National School and St Nicholas Church in the top image, taken around the turn of the nineteenth century. The card below shows St Nicholas Church School, or the National School as it was known, photographed in the early months of the First World War. The school was built in 1864, although it was originally founded in a thatched cottage during the late 1850s on the site of the present structure. During its early years, the National School had an attendance of around sixty pupils, rising to over 100 by 1870.

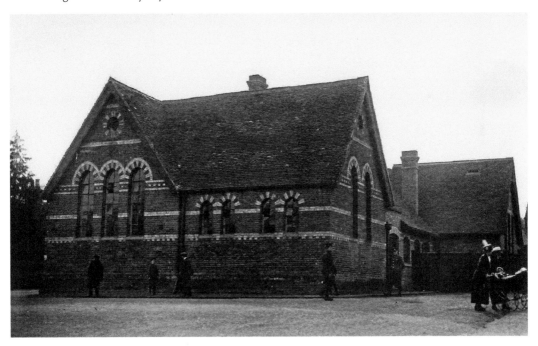

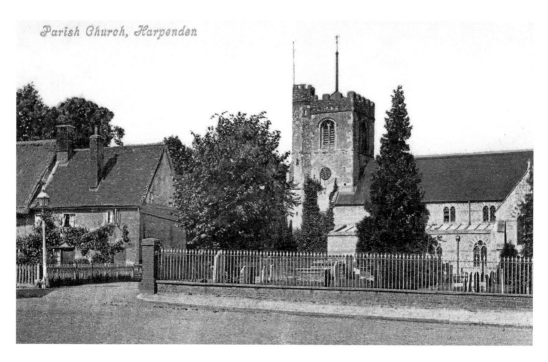

St Nicholas Parish Church

Two lovely pictures show St Nicholas Parish Church, the oldest church in Harpenden, originally built in the thirteenth century as a chapel of ease to the mother church of St Helen's in Wheathampstead. In 1859, St Nicholas became a parish in its own right. Although most of the old church was demolished in the early 1860s to be replaced by a larger building, the tower dates back to 1470 and contains a ring of eight bells, the oldest of which is dated from 1612. The new church was consecrated on 7 November 1862 with Canon Vaughan as Harpenden's first rector.

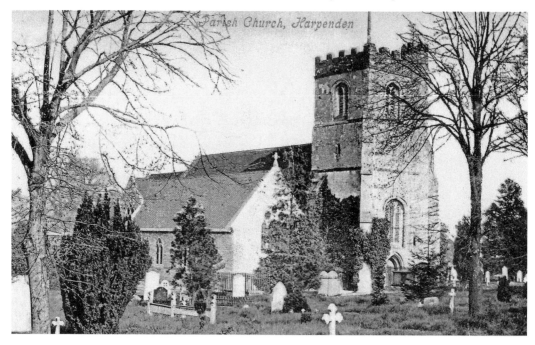

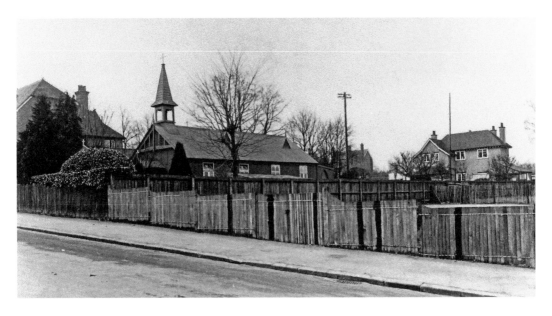

The Church of Our Lady of Lourdes

On 28 May 1905, a 'temporary' corrugated-iron Roman Catholic church was opened on a site in Rothamsted Avenue. Although only intended to serve the community for a relatively short period of time, it wasn't until twenty-four years later that the foundation stone for the present church was laid on 4 August 1928 by Cardinal Bourne. The opening was in October 1929 at a cost of nearly £20,000. The church was eventually consecrated by Archbishop Hinsley, Archbishop of Westminster on 28 May 1936, thirty-one years to the day that the original corrugated-iron place of worship had opened its doors.

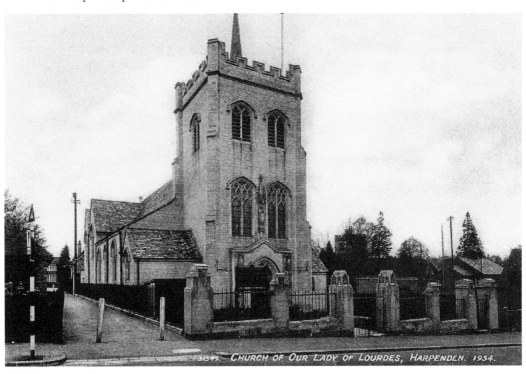

CHURCH OF OUR LADY OF LOURDES, HARPENDEN. 1934.

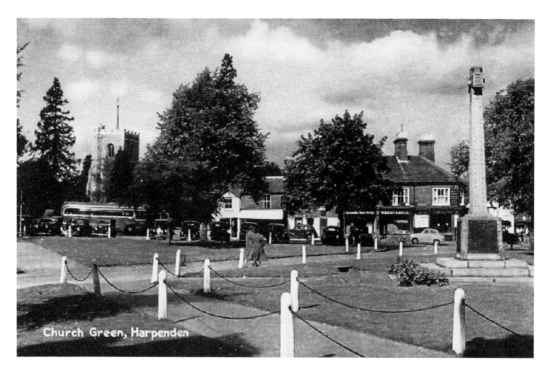

Church Green, Harpenden

Church Green I

Although thirty years separates these two charming views of Church Green, taken in the mid-1930s and 1960s, there appears to be very little change that has taken place, apart from the ongoing transition of shop ownership. It still remains a pleasant place to sit and rest awhile on a fine summer's day.

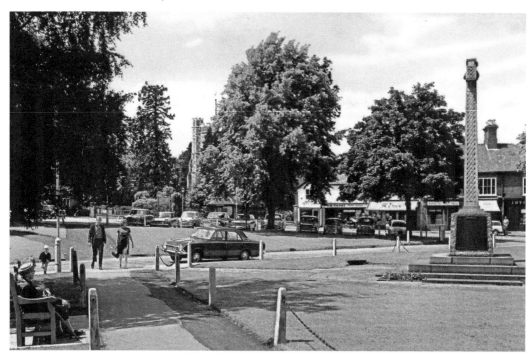

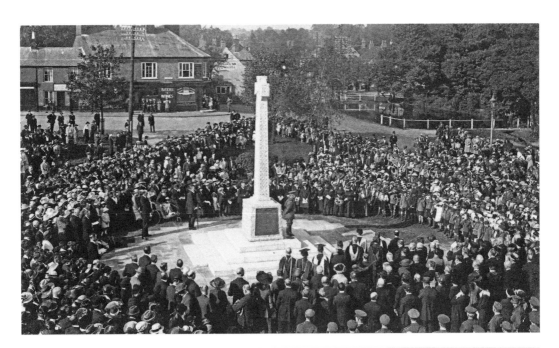

The War Memorial

The names of the 164 local men who had laid down their lives in the First World War, 'the war to end all wars', are inscribed on two gunmetal tablets fitted to the base of the granite Celtic wheel cross war memorial on Church Green – a further 110 names were added after the Second World War. The memorial was unveiled at a special ceremony on Saturday 9 October 1920 by Lieutenant-General Lord Cavan, a local man from the nearby village of Wheathampstead. As you can be seen in the above photograph, a large crowd of people, together with many important dignitaries, had gathered to witness the historic event. Just over one month later on 11 November, the memorial was again the focus of attention by the local populace as Remembrance Day was recognised to honour the war dead.

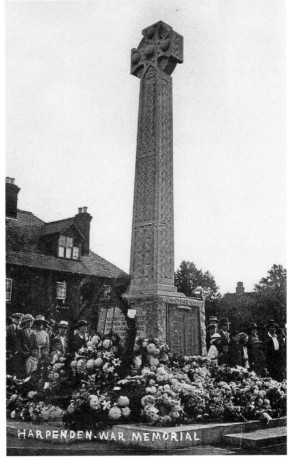

HARPENDEN WAR MEMORIAL

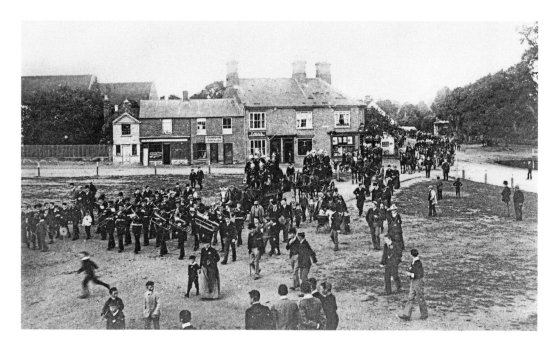

Fire Brigades

Throngs of spectators gathered to watch as rival fire brigades, accompanied by a brass band, drove their horse-drawn appliances across Church Green, as shown above in 1893, on their way to Rothamsted Park to participate in various events and sporting contests. It is not known how the Harpenden brigade fared at the end of this popular and well-attended day, but no doubt they probably gave a good account of themselves. Seventeen years later, on August Bank Holiday Monday 1910, the local service organised a series of fundraising events, below, towards the purchase of a second-hand Shand & Mason steam-operated fire engine, popularly known as a 'steamer', which they were eventually able to purchase in 1912 for the princely sum of £185.

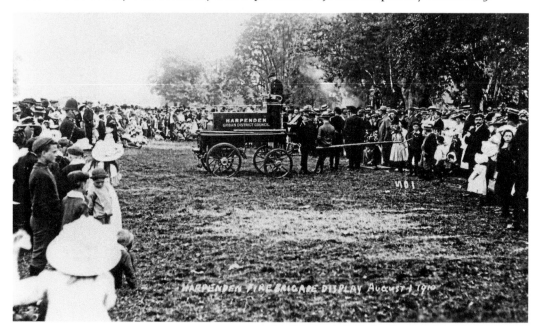

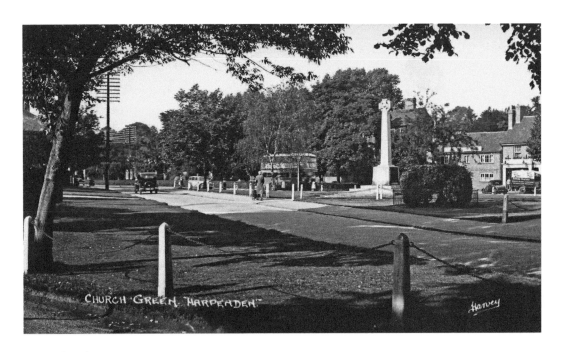

Church Green II

The unused real photograph postcard above, by Oliver Harvey from the 1930s, shows a delightful view of the War Memorial and the High Street with the Cross Keys public house just visible in the background on the right-hand side. A royal milestone is seen being celebrated on the other side of the green, where spectators have gathered to watch a procession of decorated floats and tableaux on the occasion of the Silver Jubilee of their majesties King George V and Queen Mary in May 1935. The rare postcard below also shows some of the various business premises of the day decked out in red, white and blue bunting.

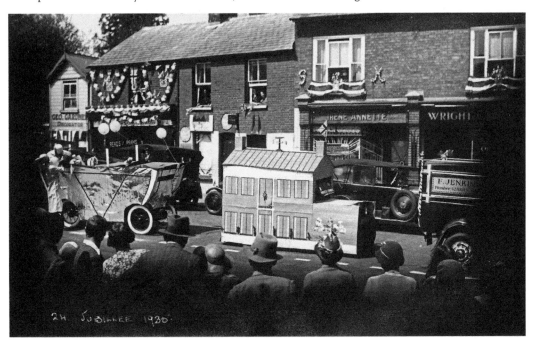

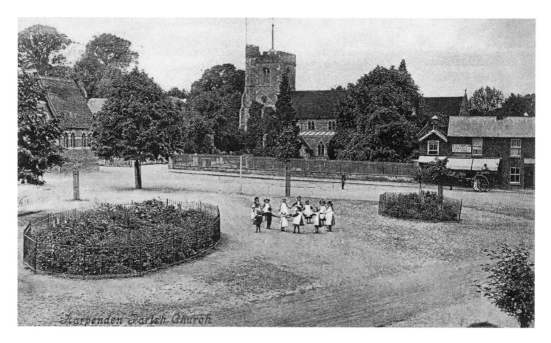

Children at Play

These two postcards from the early 1900s show groups of children at play on Church Green, probably pupils from the nearby National School. Although they have possibly posed for the photographer, the images nevertheless make a very pretty picture, as well as giving an excellent insight into how this part of the village looked at the turn of the nineteenth century. The school can just be seen on the left of the top image, while the premises of fishmonger Robert George Sampson are located at the end of the row of shops next to the small weather-boarded building. This was built in 1857 on the site of the village 'lock-up'.

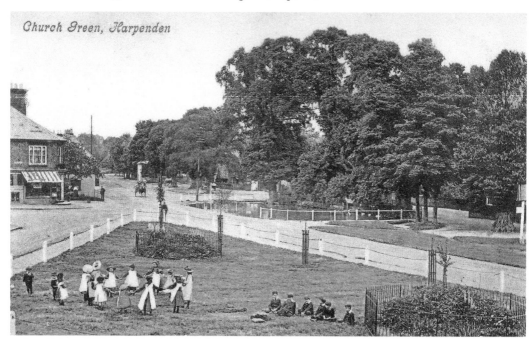

CHAPTER 4
IMAGES OF SOUTHDOWN

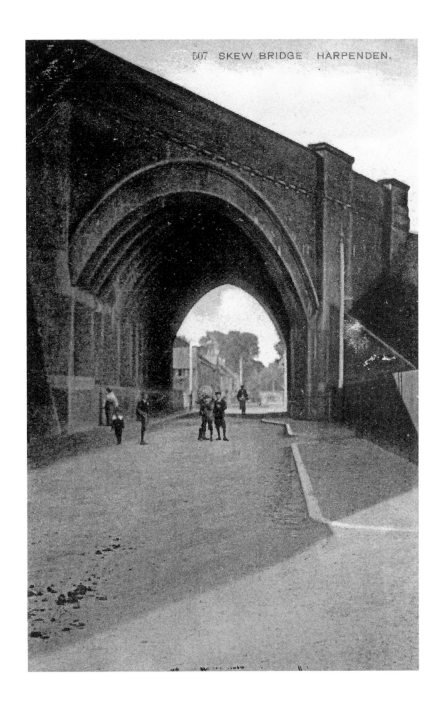

507 SKEW BRIDGE HARPENDEN.

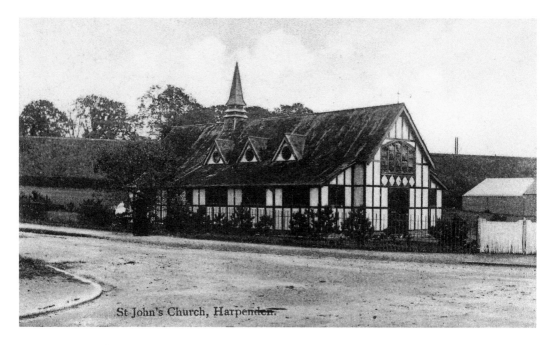

St John's Church, Harpenden.

The Paper Church

On the night of New Year's Eve 1905, the original St John's Church, known as the Paper Church because of its timber frame construction, caught fire with the building being completely destroyed. The church had been erected in 1895 on the corner of what was then Wheathampstead Road, now Southdown Road, and Crabtree Lane. Following this devastating event, a new church, designed by noted architect Mr F. C. Eden, was built a short distance away in St John's Road. The new church was consecrated on 2 March 1908 with the Crabtree Lane site eventually being developed for housing.

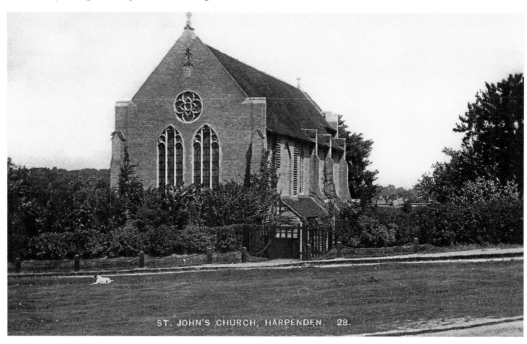

ST. JOHN'S CHURCH, HARPENDEN. 28.

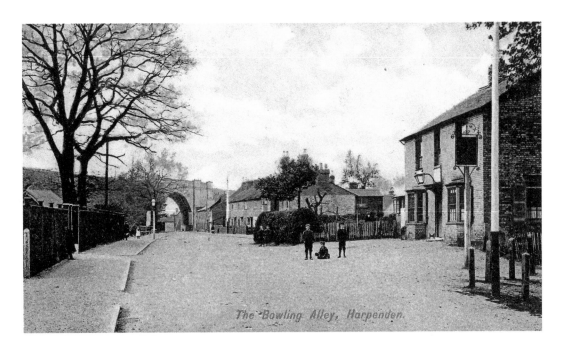

The Bowling Alley, Harpenden.

The Bowling Alley

Part of Southdown, also known as the Bowling Alley, is shown above in a card posted on 11 August 1906 with the Queen's Head public house on the right and Skew Bridge in the distance. The real photograph card below taken in the 1920s/1930s depicts the road from the opposite direction with the pub on the left and the common in the distance. The origin of the area known as the 'Bowling Alley', according to a local source, is that the name comes not from the game but from the shape of a field. In 1784, there were two fields, Upper and Lower Bowling Alley which were later combined before Longfield Road was eventually built over them.

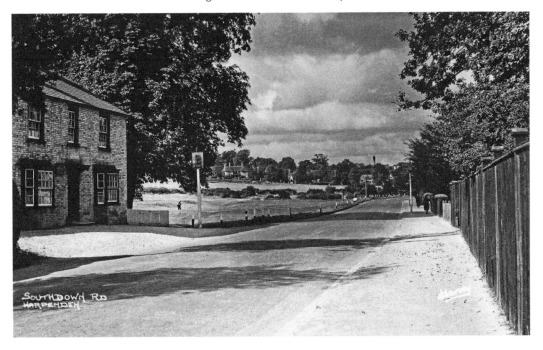

SOUTHDOWN RD
HARPENDEN

45

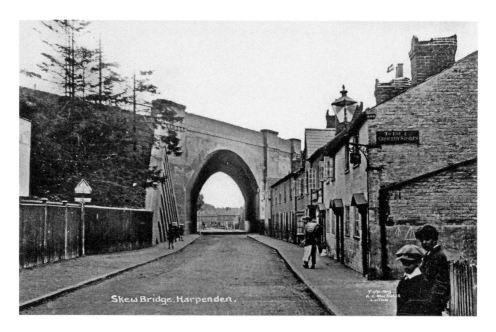

Skew Bridge I

These two wonderful old pictures show Skew Bridge in the Bowling Alley, Southdown. The bridge, described as 'an amazing marvel of engineering' at that time, was built in 1865 for the Midland Railway line that was to pass through Harpenden, and which opened in 1868 with two tracks. Skew Bridge was widened in 1891 and a further two tracks added. The old cottages on the right were demolished in the 1960s when the site was redeveloped with modern housing. The postcard image below, taken by local photographer Oliver Harvey and posted on the 15 November 1937, was captured at just the right time as the London train passed over the bridge on its approach to Harpenden.

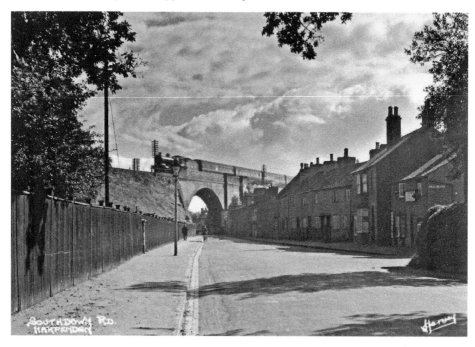

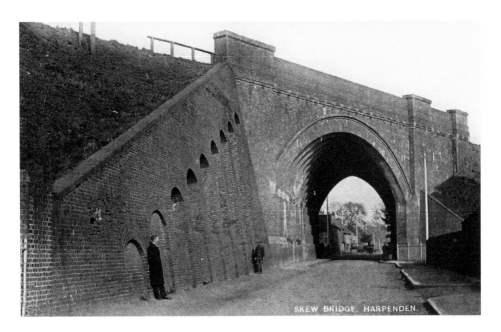

Skew Bridge II

Seen from the other side of Skew Bridge in the top image, the Queen's Head public house can just be seen in the distance through the arch beyond the row of cottages. The entrance on the right leads to the Harpenden Gas Light and Coke Company formed in 1864, which mainly supplied domestic users in the village. Street lighting though did not start until the 1880s. Pictured further back down the road, and depicted in the lovely watercolour painting below, is the Plough and Harrow, a well-frequented local hostelry suitable for its many patrons seeking a convivial drink, with Skew Bridge in the background. (*Below*: Courtesy of Les Bott and the Pilkington Group Ltd)

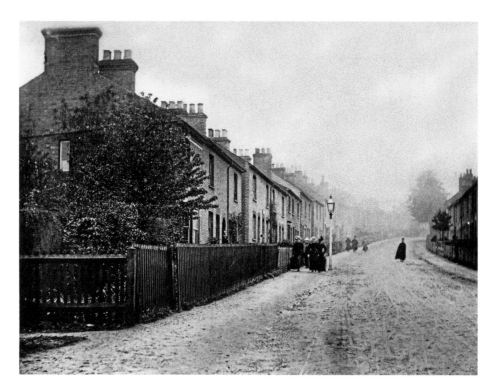

Cravells Road

It is a chilly day as this group of ladies approach the bottom of Cravells Road in 1890, possibly walking to Southdown Methodist Church for Sunday morning service. The photographer who snapped the bottom image looking down the road in the card posted on 24 November 1914, three months after the outbreak of the First World War, appears to have attracted the attention of some of the residents as they stood outside their houses. Today, apart from the numerous cars parked in the road, there appears to be very little outward change to this early twentieth-century scene.

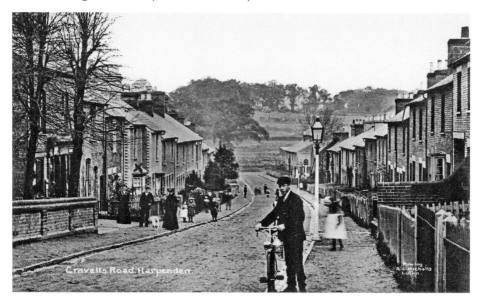

Cravells Road, Harpenden.

Bowling Alley Harpenden.

Piggottshill Lane

A small crowd of curious bystanders gathered in Piggottshill Lane, right, on 20 May 1930 to watch as workmen arrived to fell a large tree following a decision by the Urban District Council to facilitate road widening due to the steady increase in motorised traffic. With a local photographer in attendance, the task was soon accomplished. The above snapshot shows the Bowling Alley in the 1880s with Charles Ogglesby's blacksmith's shop located in the small building on the right which opened for business in 1873.

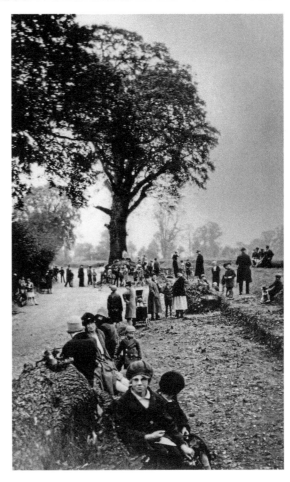

CHAPTER 5

ALONG THE VILLAGE
HIGH STREET

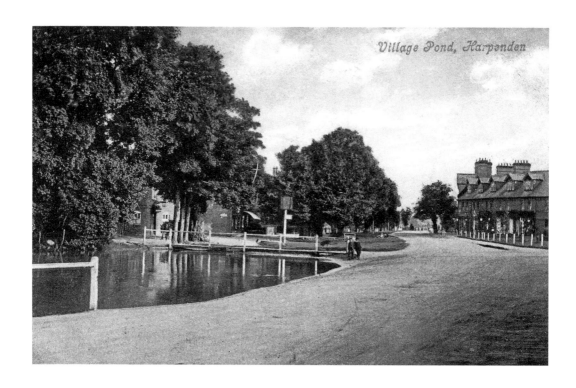

Village Pond, Harpenden

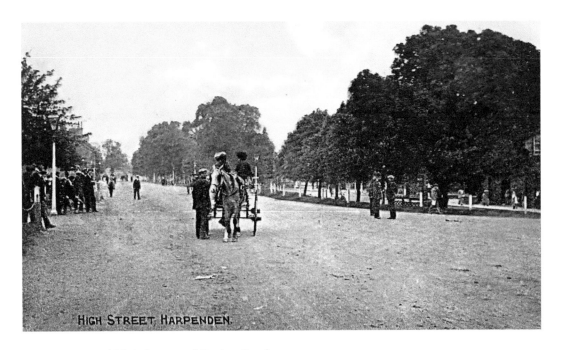

HIGH STREET HARPENDEN.

Junction of High Street and Station Road

Taken in the early years of the twentieth century, the High Street portrayed above at the junction with Station Road was then a quiet and peaceful thoroughfare, unlike the traffic congestion of today's ubiquitous motor car. A large group of men can be seen enjoying a pint of ale outside the nearby George Hotel on the left, possibly in preparation for attending the horse races on the common that took place each year during the week before the Derby. Another delightful view, again looking northwards, was captured in the mid-1930s, where the image includes ornate gas lamp standards, a lovely old single-decker bus and an Austin 7, as well as the new Belisha beacon pedestrian crossing outside the Railway Hotel. These crossings, so named after the Minister of Transport, Leslie Hore-Belisha, were introduced in 1934 and consisted of spherical orange lamps mounted on black and white posts.

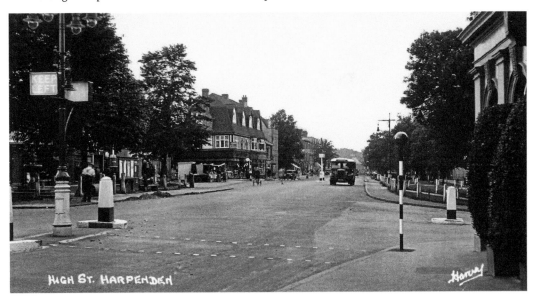

HIGH ST. HARPENDEN

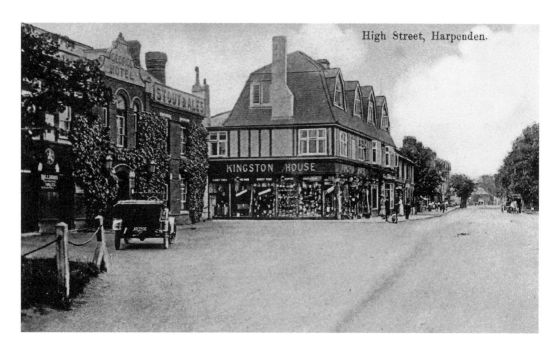

The George Hotel

With just a horse and cart and the lovely old touring motor car parked outside the ivy-covered George Hotel, this tranquil scene of the High Street in 1920 is traffic-free, something which cannot be said for today's busy roads around Harpenden. A familiar sight on the George forecourt in those far-off days would have been the stalls of Brown's, a greengrocer and Hammett's, a fishmonger, the latter travelling from Luton each day. Mr Hammett later opened a shop in 1926 further along the High Street. The house next to the hotel had once belonged to Dr Kingston, one of the village doctors, and was eventually purchased by Henry Salisbury in 1912 who demolished it to build a new shop, which he called Kingston House Stores, to sell 'household and general furniture'. The view of the George below was taken in the early 1960s.

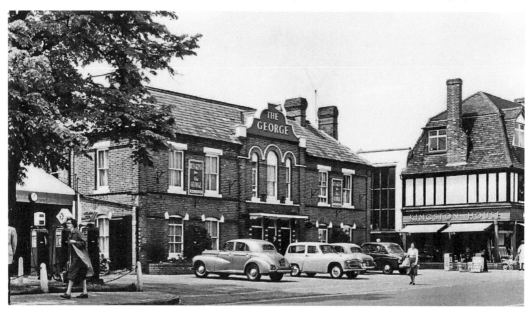

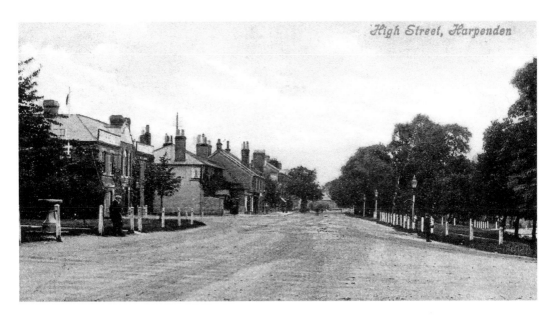

High Street, Harpenden

High Street I

Over sixty years separates these two coloured images of the High Street, which clearly illustrates the many changes that have taken place in the intervening period of time. It is interesting to note that the drinking fountain featured on the extreme left of the postally used card of 1908 above still exists – today it occupies pride of place on a new site just a few yards out of camera shot. The fountain was presented to the people of Harpenden by Sir John Bennet Lawes in 1890, who besides founding Rothamsted Experimental Station was also Lord of the Manor and a great benefactor as well. The inscription on the fountain reads, 'Presented by Sir John Bennet Lawes, Bart. – 1890 – Restored by Public Subscription – Collected by the BWTA (Harpenden Branch) – 1914'. The BWTA were the British Women's Temperance Association. At one time many years ago, a brass cup on a chain was attached to the fountain, but this has long since gone.

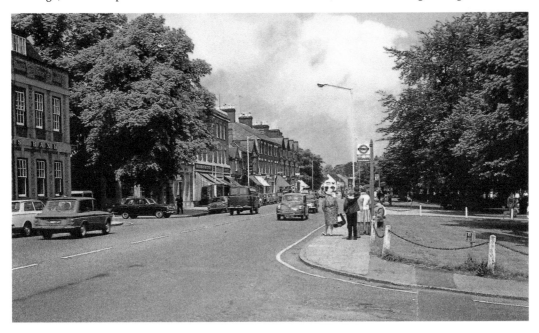

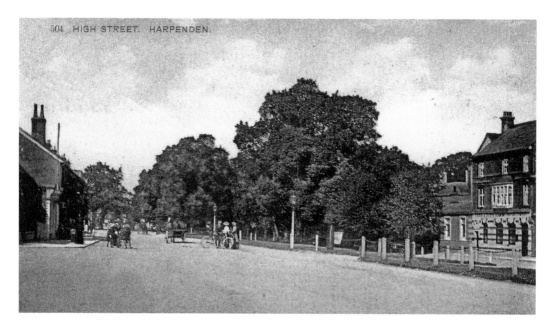

High Street II

Another delightful postcard dated 29 August 1907 shows the leisurely pace of life that existed in the village during the early part of the twentieth-century, although it would be impossible today to stand and gossip in the road as the small group are doing. Just visible on the right is the local branch of the London County and Westminster Bank, now the NatWest Bank, with its distinctive brick facade at No. 21 High Street. Another view of the bank in the unused card below also includes the premises of Pellant & Son, high class jewellers and watchmakers on the corner of Vaughan Road. A distinguishing feature of Pellant's was the large ornate clock that was located just above the shop's name sign, remaining there until closure in the 1970s.

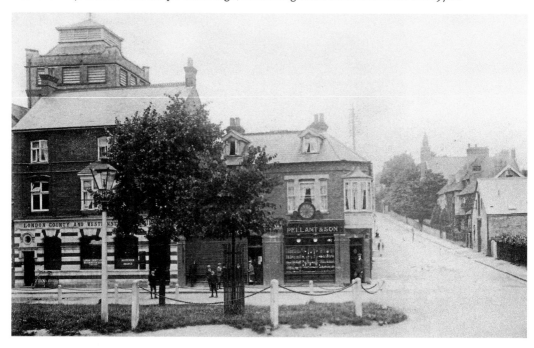

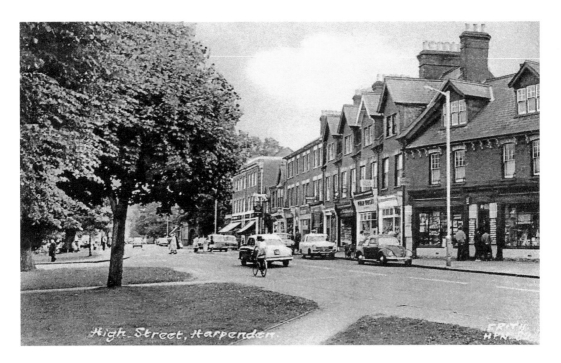

High Street Looking South

Photographed in the early 1960s, these images capture the view southwards looking towards the common. Probably what makes this thoroughfare so attractive are the well-manicured greens that extend the length of the wide boulevard that is the High Street, from Station Road to the sensory garden that was once the village pond opposite the Old Cock Inn. Visible in both cards is the distinctive feature of a large white lion model situated on a wrought-iron bracket advertising the Victorian public house of the same name. Although no longer a pub, the whereabouts of the lion remains a mystery to this day. (*Above*: Courtesy of the Francis Frith Collection)

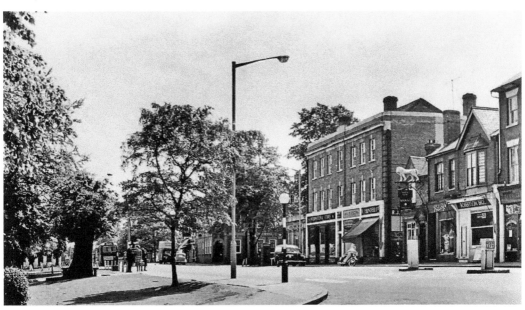

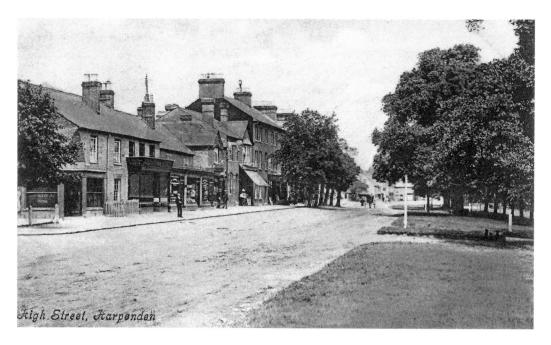

High Street, Harpenden

Celebrations

Just beyond the cluster of elm trees, seen above in the centre of the picture, the photographer took a snapshot below, one of many that day, of Church Green from the High Street. The occasion was the coronation of the new King George V and Queen Mary on Thursday 22 June 1911 following the death of Edward VII the year before. Like every other town and village throughout the country, Harpenden was eager to celebrate this exciting event, festooning their houses, shops and pubs with numerous flags and coloured bunting. The tower of St Nicholas parish church looms majestically above the tree line, where no doubt a peal of bells was rung to mark this joyous royal occasion.

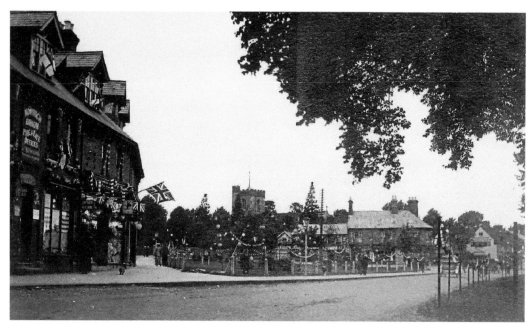

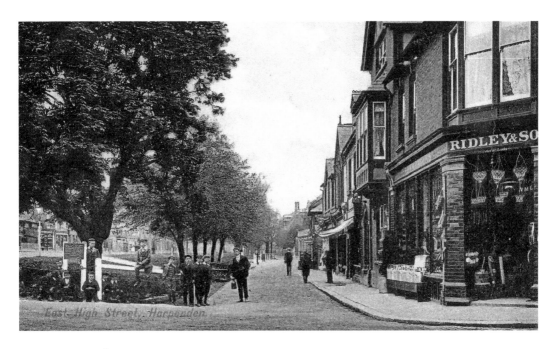

Lower High Street

These two lovely old postcards of Lower High Street were photographed from Station Road, the top one by Daniel Barton Skillman in the early 1900s, which shows one of the little rustic bridges over the narrow stream that flowed alongside the road from the Cock Pond. The appearance of the photographer with his bulky camera and tripod was always guaranteed to attract a great deal of inquisitive interest, as can be seen by the group of young lads gathered on the corner. On the opposite side of the road is Ridley's ironmongery business, which continued to trade until it closed in 1933 when the Midland Bank (now HSBC) acquired the premises. A similar snapshot in the 1930s was taken by Cecil Hallam.

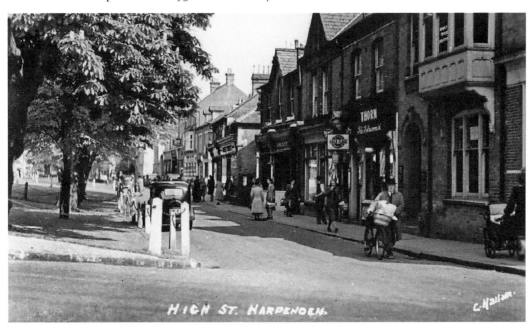

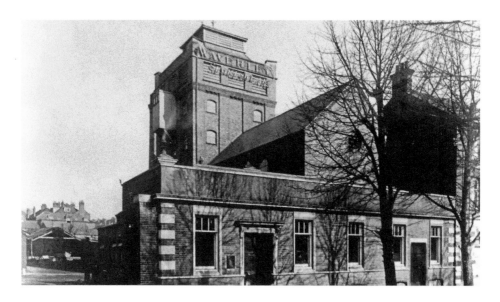

Waverley Mills

During the early 1890s, the two breweries that existed in Harpenden at the time, Mardall's and Healy's in Lower High Street, merged until the amalgamated brewery was subsequently bought by Richard Glover in 1897. The buildings were then modernised and the tower, a local landmark, was erected. With a further purchase in 1902 by Prior Reid's of Hatfield, this made the brewery one of the largest in the county. When the business eventually closed down in 1920, the premises, now renamed Waverley Mills, were taken over by Mr George Bevins who manufactured sportswear, hosiery and knitwear. The firm continued trading for a further sixteen years before the buildings were demolished in 1936 and a Woolworths, Boots and Sainsbury's were constructed on the site. With Woolworths now gone and Sainsbury's operating from further along the High Street, part of the building is now occupied by Harpenden Public Library. (*Below*: Courtesy of Judge Sampson Ltd, Hastings, www.judgesampson.com)

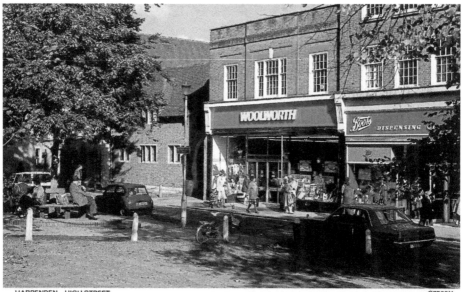

HARPENDEN HIGH STREET C7509X

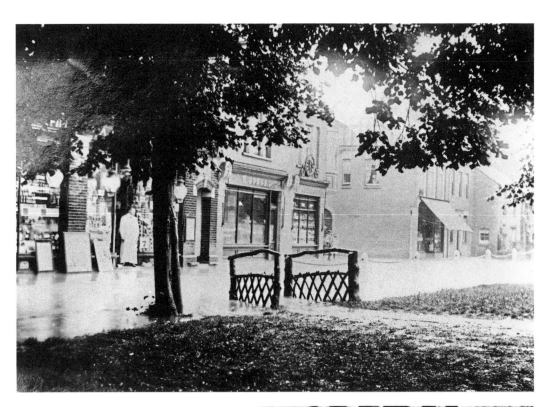

The Lower High Street Stream
Sometimes grandly referred to as the River Harp, the small stream that flowed along Lower High Street was mainly dependent on rainwater. To facilitate pedestrians crossing the stream, a number of charming little rustic bridges were constructed at intervals from the Cock Pond to Station Road, one of which can be seen above near the junction with Vaughan Road. In August 1879 following two hours of torrential rain, the village was flooded from Sun Lane to Wheathampstead Road and a Jack Healy is reputed to have swum from the pond to the gravel pits – a magnificent feat. During 1928, the Cock Pond was filled in and the water piped underground to ponds on the common as part of an extensive drainage scheme. The snow scene on the right, taken around 1920, shows the stream passing through a brick culvert with one of the rustic bridges and Church Green in the background.

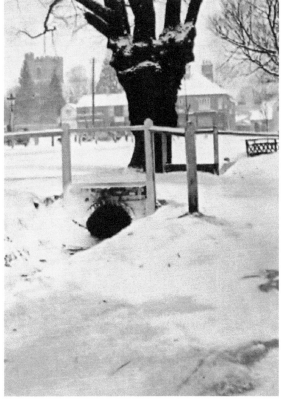

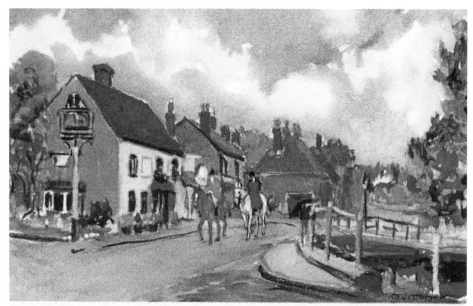

Harpenden: Going to the Meet.

The Old Cock Inn

Two lovely postcards of the Old Cock Inn, one a watercolour painting titled 'Going to the Meet', where the huntsmen are seen riding through the High Street en route for the common from where the hunt would have commenced. The Cock Pond can be seen on the right. Interestingly, two of the nineteenth-century landlords of the pub both had additional occupations. Around 1851, Joseph Trustram, who was also a carpenter, used to hire out threshing tackle with a team of six horses to local farmers, while the landlord in the 1890s was listed as a wheelwright. The picturesque wintry scene of the Cock Pond was taken outside the Cross Keys public house on the opposite side of the road by the prolific local photographer, Cecil Hallam.

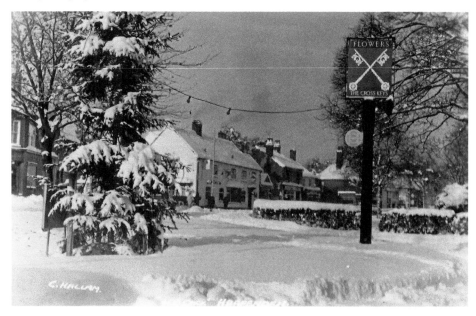

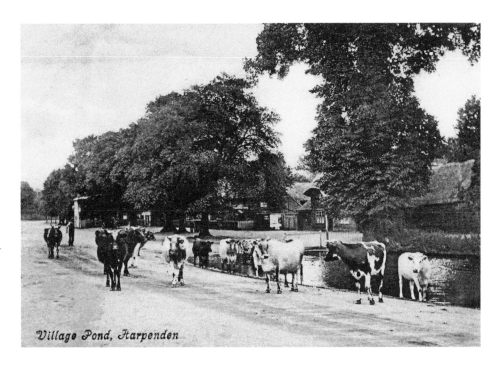

Village Pond, Harpenden

The Cock Pond

Looking north along the High Street, there is a timeless quality about these rural postcards where both cattle and horses are seen drinking their fill. The coloured image below, posted on 6 May 1912, shows the pond now surrounded by a fencing rail with the telegraph poles as an indication that the telephone had arrived in Harpenden, the first users being connected via Luton to the National Telephone Company circa 1902/3. The legend on the side elevation wall of the Old Cock Inn advertises 'Beanfeasts and Parties Catered For'. The Beanfeasts were very popular, where people from as far away as London would travel to Harpenden for a 'feast' at one of the village pubs or inns.

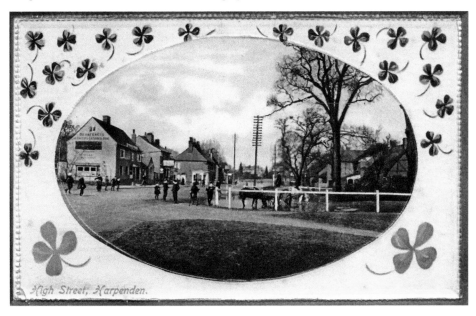

High Street, Harpenden.

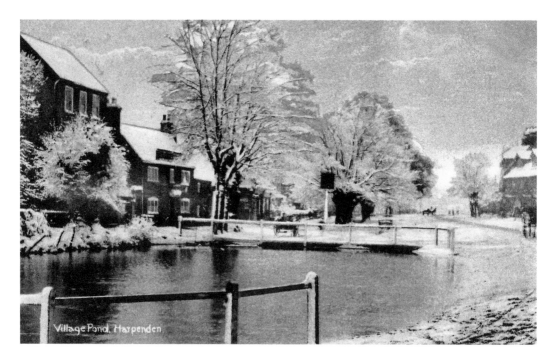

Village Pond, Harpenden

Looking South Along the High Street

These two charming images captured in the early years of the twentieth-century portray the same view of the Cock Pond in winter and summer, looking south along the High Street, a perfect example of the quintessential country village. To the right of the picture below is a row of Victorian villas known as the Island Site. Built in 1890, the building replaced Island Cottage, which had been occupied by a Mr F. G. Lockhart during the 1870s and 1880s. Following demolition of the cottage, the villas with their distinctive dormer windows occupied the area between the High Street and Leyton Road at the rear. As well as being private homes, there were some shops, including the post office, which had moved there in 1898, although by 1905 had transferred to new premises on Lower High Street.

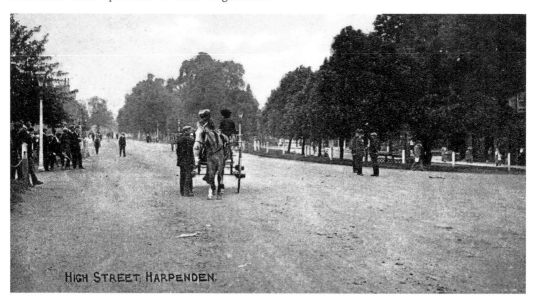

HIGH STREET HARPENDEN.

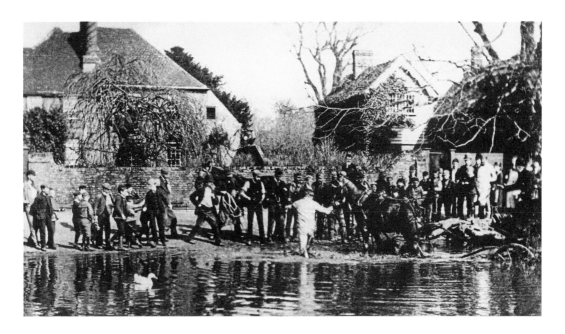

William Hogg

Well-known local cabbie William Hogg caused quite a stir in 1891 when he drove his horse into the Cock Pond to cool off, only for the poor animal to get stuck in the mud. Soon helping hands had managed to get the animal back on dry land again, presumably none the worse for the experience as can be seen above, although within a few hours the whole village knew about the unfortunate incident. Visible on the edge of the pond in the 1907 Skillman card below is a small kennel used to provide shelter to a pair of swans. Unfortunately, one was accidentally run over and passed to the common keeper for disposal. However, it just so happened that the Rothamsted Allotment Club Committee were due to hold their annual dinner, so instead of their usual side of beef, the members dined on roast swan that year.

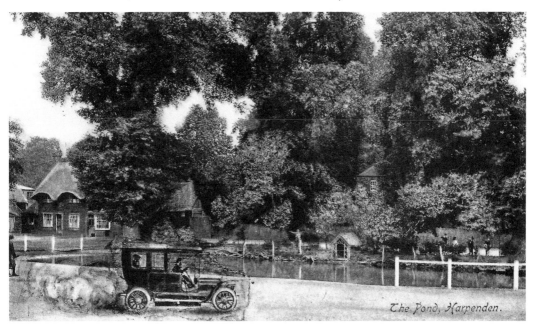

The Pond, Harpenden.

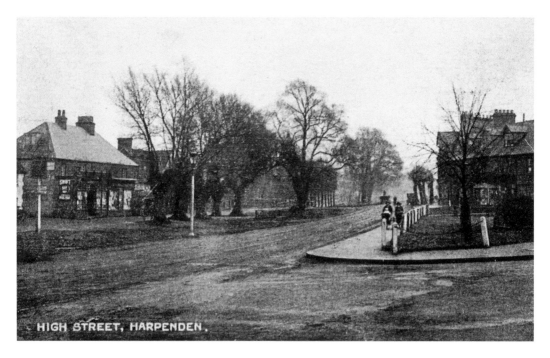

HIGH STREET, HARPENDEN.

The Village Centre from Church Green

Another snapshot taken by local photographer Daniel Barton Skillman, the card was posted on 26 October 1918 in the closing stages of the First World War. Photographed on a bleak-looking day just beyond the Old Cock Inn, the view facing south is of the High Street, Lower High Street and the stream, with the Island Site building on the right. The 1930s postcard illustrates the Island building more prominently, with the Cross Keys pub sign on the left. The photo was taken where the Cock Pond used to be prior to being filled in a few years earlier.

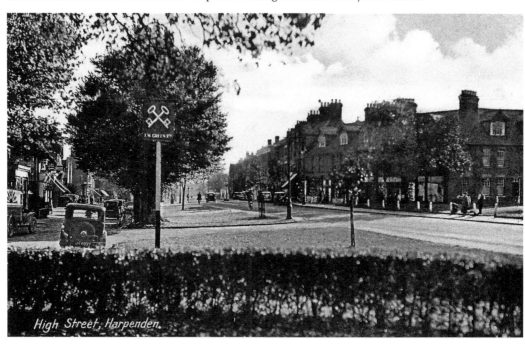

High Street, Harpenden.

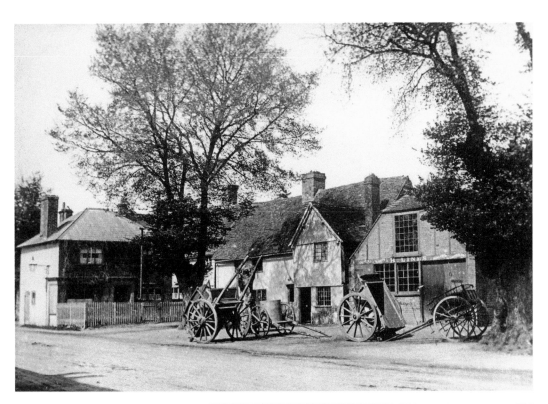

The Village Smithy

Situated near the Cock Pond, the local blacksmith's forge was built in 1820 and closed in 1957 after being worked by three generations of the Lines family. Many older residents will remember Mr Lines shoeing a horse or pumping up the fire with his bellows as a red-hot metal shoe was fitted to a horse's hoof. In the days before tarmacadam, a hand-operated water cart was used to lay the dust on the stone-surfaced roads, as can be seen in the picture on the right. The forge was demolished in 1960 and a parade of shops with flats over called Anvil House now occupies the site.

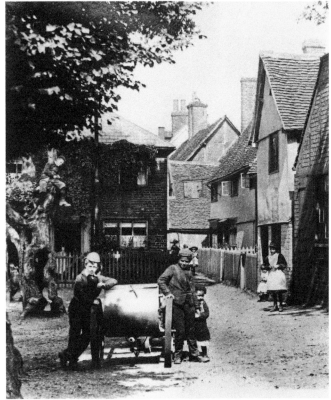

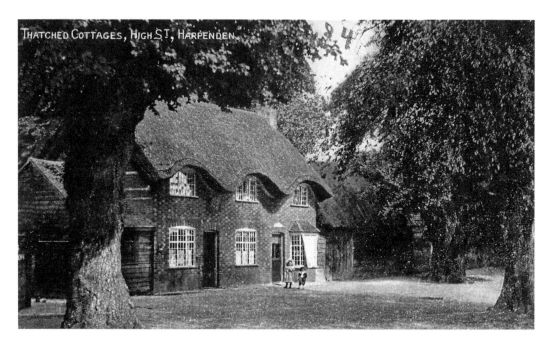

The Thatched Cottages

Just north of Bowers House, once the home of Dr Frederick Robert Spackman and Dr W. H. Blake respectively, and close to the village pond, stood this picturesque pair of thatched cottages. In the late 1930s, having deteriorated and fallen into a state of disrepair, the cottages were demolished to make way for Reads' Motor Works' new showrooms as an extension on the recently constructed Bowers Parade. The demise of Jasmine Cottage, below, came in 1960 at the same time as the forge. Although Bowers House, just out of camera shot, still exists, it is hidden from view behind the shop buildings of the Parade.

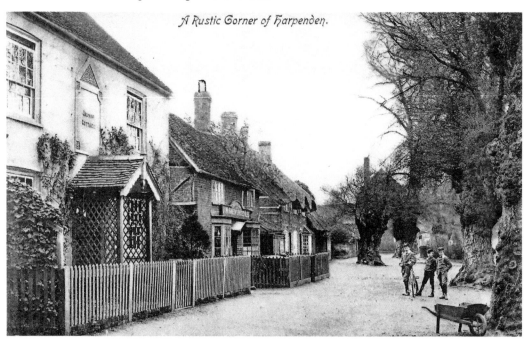

A Link with the Past

At the north end of the High Street, just before Sun Lane, is this lovely tranquil-looking walkway that photographer Cecil Hallam described as 'A Link with the Past', a truly apt description. The small building in the foreground, known as the Island Cottage, was at one time occupied by Fred Timson, 'Hand Sewn Bootmaker and Repairer'. The sender of this card writes, 'Overleaf is the little cobbler's shop, Timson's, where we have all had shoes repaired for over forty years. Timson himself has just retired after sixty years work in it. Love to all, your affectionate uncle Selwyn'. The real photograph card below, also by Hallam, depicts Sun Lane Cottage, which was drastically altered in the late 1920s when the northern end was demolished to facilitate the widening of Sun Lane. The building is now occupied by a leading local estate and letting agent.

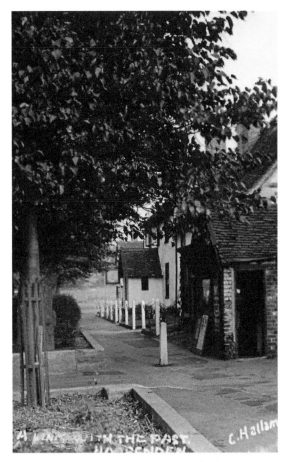

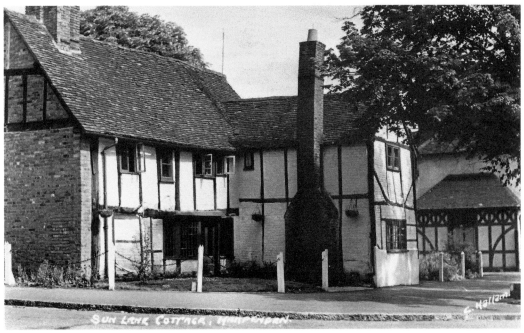

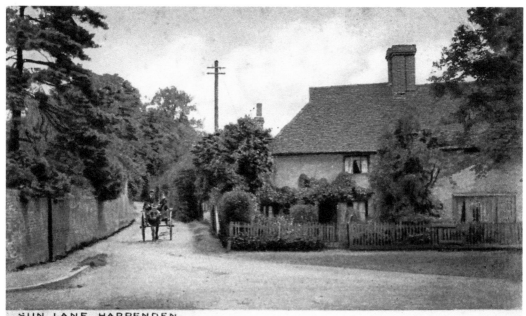

SUN LANE, HARPENDEN.

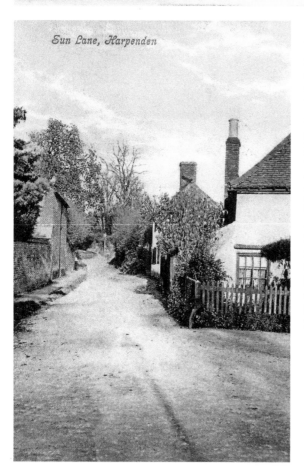

Sun Lane, Harpenden

Sun Lane

When comparing these two colour images with the previous picture, it can be seen how Sun Lane Cottage used to look before part of the building was demolished. The brick wall to the left of both illustrations marks the southern boundary of Harpenden Lodge. Constructed in the 1790s by Sir Charles Morgan, the house was sold to Major General James Murray Hadden in 1804 when it was known as Harpenden Lodge. Although Hadden died in 1817, the family continued to live there until 1857 when it was purchased by Gerard Wolfe Lydekker, remaining in his family until 1979 before the lodge was eventually converted into three luxurious self-contained flats that became occupied in 1985.

CHAPTER 6

FROM BATFORD IN THE LEA VALLEY TO STATION ROAD

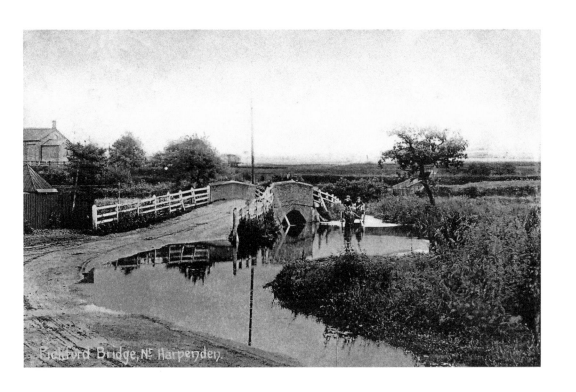

Batford Bridge, Nr Harpenden.

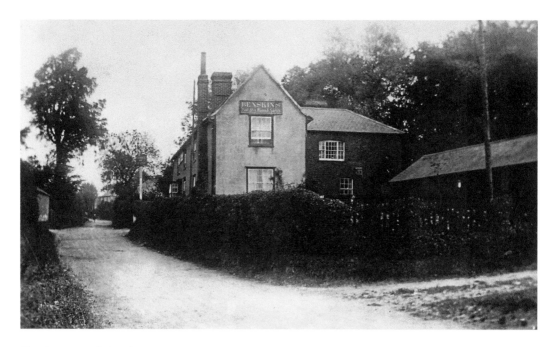

The Marquis of Granby

During the 1930s, mine host of this quaint eighteenth-century inn situated at the bottom of Crabtree Lane was one Alfred Edward Mundy, Alf to his many regulars, some who are seen below enjoying a sociable drink in the pub's beer garden. Although fully licensed, Alf also provided teas and ices, which were always welcome on a hot summer's day. Being so close to the adjacent River Lea and ford, the old pub used to have a clear view of the riverside scenery, but over the intervening years tall trees, shrubs and vegetation have gradually obstructed the outlook. Originally called the Swan, the inn became the Marquis of Granby in 1799.

"The Marquis Gardens."

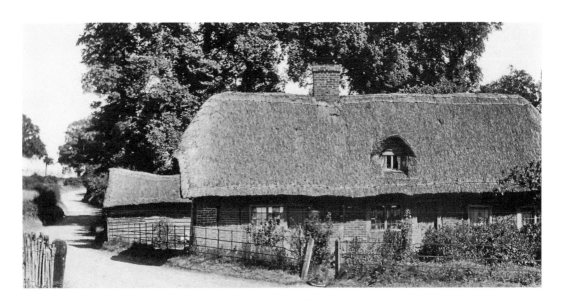

The Thatched Cottage and Batford Mill

Just across the River Lea on the opposite side to the Marquis of Granby is this lovely old seventeenth-century thatched cottage. The photograph from which the postcard was produced was taken around 1925 when the cottage comprised three dwellings, now converted into one. Earlier occupants included an agricultural worker and William 'Shep' Arnold, a local shepherd, who with his wife, lived there with his large family of thirteen children. Unlike today, there was no indoor sanitation and water for washing had to be drawn from the nearby river. A spring close by provided the drinking water. A short distance away was Batford Mill, as depicted below in the late 1930s, one of four in the parish of Wheathampstead, which included Harpenden, all of which were mentioned in the Domesday Book of 1086.

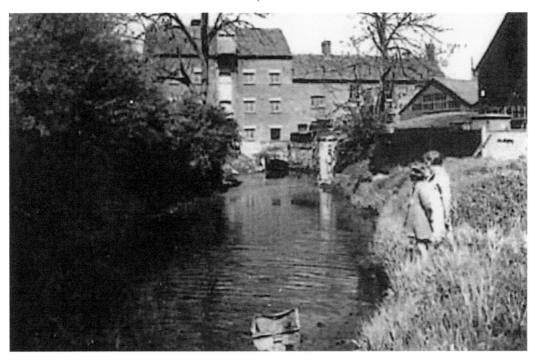

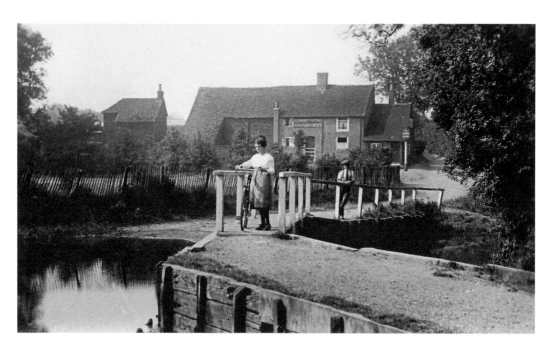

Fords and Bridges

An early view of the ford across the River Lea, taken from the footbridge, illustrates how close the Marquis of Granby was to the waterside before the outlook was eventually obscured by high trees and shrubs. Crabtree Lane can be seen on the right next to the pub. The coloured image is of Pickford Bridge at the turn of the nineteenth century where the card, which was sent on 19 August 1909, shows some of the Great Northern Railway rolling stock just visible in the background. The building on the left is the railway's goods shed.

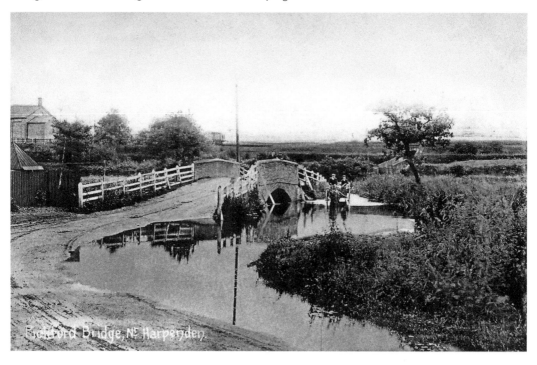

Pickford Bridge, N⁎ Harpenden.

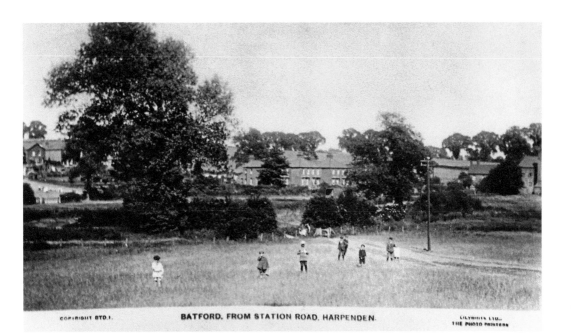

BATFORD, FROM STATION ROAD, HARPENDEN.

Batford and Coldharbour

Two delightful early Lilywhite postcards show children at play in a field at Batford, taken from Station Road, although the arrival of the photographer probably provided more interest than their childhood games. The bottom image shows the view from Batford at the end of Northfield Road, down the slope to the Lower Luton Road and across the flood plain to the cottages of Coldharbour Lane. To the right of the picture, cars on the Lower Luton Road can be seen passing the foot of Bower Heath Lane where there were some cottages on the corner, since demolished. Just visible on the skyline are some buildings of Cooters Hill Farm.

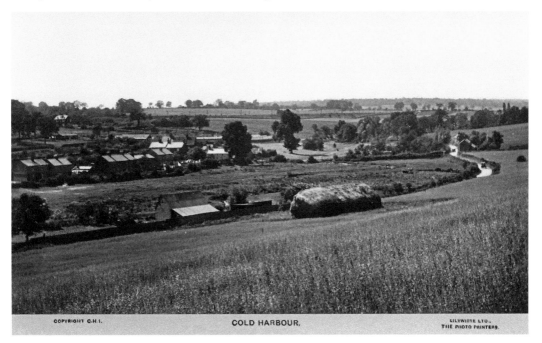

COLD HARBOUR.

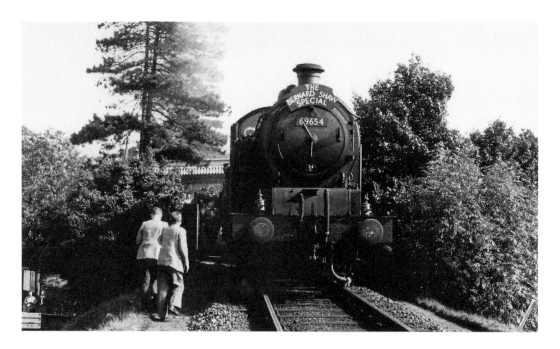

'The Bernard Shaw Special'

A nostalgic trip back in time to the wonderful age of steam is portrayed in these two lovely photographs of locomotive No. 69654 – 'The Bernard Shaw Special', pictured on the same day as it paused for a while at Wheathampstead Station before continuing to Harpenden East Station on the Great Northern Railway branch line. The event was one of a series of day excursions that ran from either the Elephant & Castle station or Clapham Junction in London to Harpenden via Wheathampstead, where devotees of the renowned Irish playwright, George Bernard Shaw, would alight to visit the home of the great man at Shaw's Corner, Ayot St Lawrence. Shaw died on 2 November 1950 aged ninety-four.

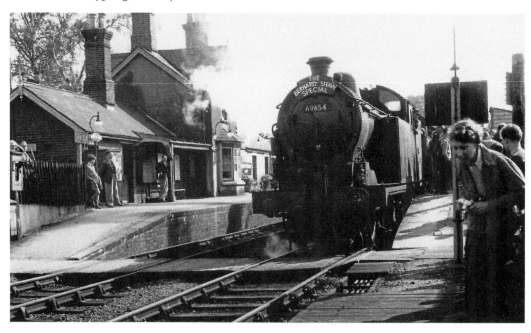

NEAR ST. GEORGE'S SCHOOL, HARPENDEN.

St George's School I

This colour postcard dated 8 April 1909 shows a tranquil part of the surrounding area to the prestigious Harpenden public boys' school, St George's. Located in Carlton Road, the land on which the school was built had been owned by Mrs Mardall, a considerable landowner in the village who named the road after the village in Cambridgeshire where she had previously lived. Building of the new Victorian Gothic-style, school commenced in 1885 with possession taken at the end of January 1887 under the headmastership of Robert Henry Wix. Following completion of a permanent chapel that replaced the temporary iron structure in 1891, a service of dedication took place on Tuesday 19 May of that year, which was officiated by the Bishop of St Albans and the headmaster.

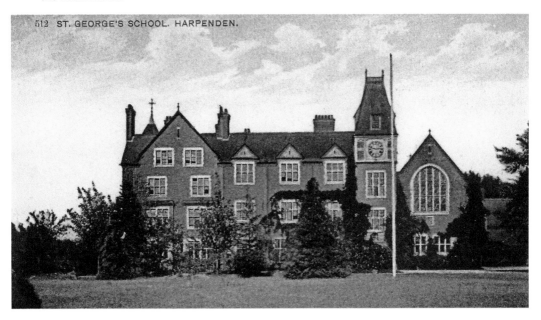

512 ST. GEORGE'S SCHOOL. HARPENDEN.

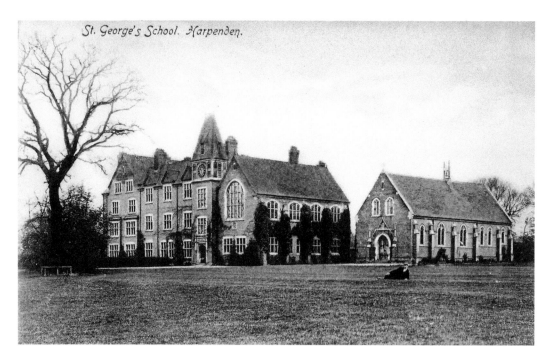

St. George's School. Harpenden.

St George's School II

The two cards featured here show the impressive school buildings and chapel in the early 1900s and again in the late 1930s. Following the headmaster Mr Wix's retirement in 1904, the school buildings were leased to a branch of the United Services College from Westward Ho but only remained for two years, moving out in 1906. The present St George's School opened in June 1907, having been founded by the Reverend Cecil Grant who had up until then been headmaster of a co-educational school in Keswick. The school celebrated the centenary of its foundation in 2007.

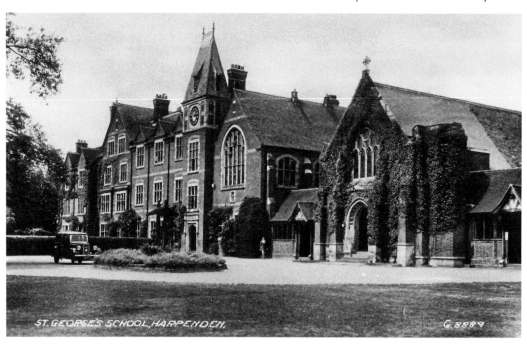

ST. GEORGE'S SCHOOL, HARPENDEN. G.8889

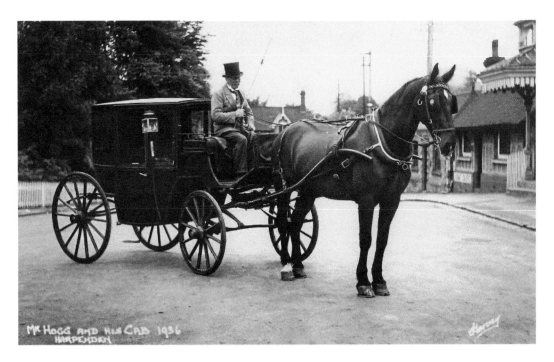

Station Approach

Although the age of the horse-drawn cab was sadly fast disappearing by the mid-1930s, William Hogg and his cab, seen above in an Oliver Harvey photo waiting for a fare outside Harpenden Station, was still popular for many evening commuters who often favoured this mode of transport to the motorised taxis. William continued working until his death aged sixty-five in 1936. The small buildings just visible to the right of Station Approach were once the offices of several local coal merchants, but today are enjoying a new renaissance as retail units. The picture postcard below dated 3 September 1906 shows passengers waiting to board the London train that has just arrived at Harpenden.

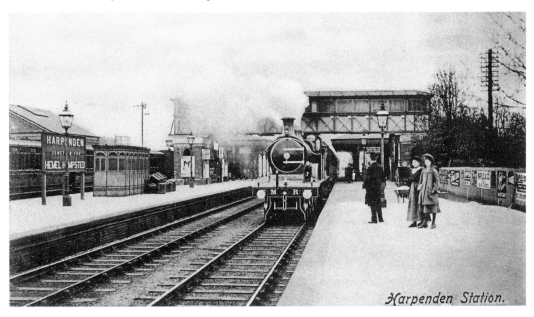

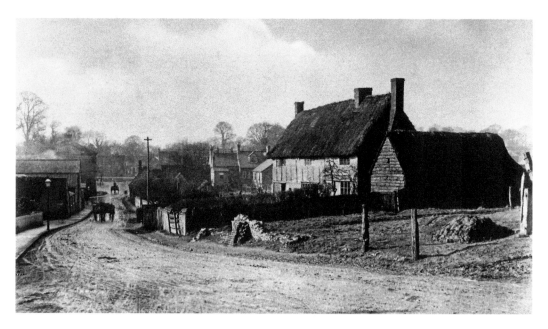

Station Road I

Originally called Staker's Lane, this early image depicts Station Road in 1896 prior to any development taking place, although the period between the First and Second World War was a time of great expansion. This was particularly relevant during the 1930s as farmlands between the High Street and Lower Luton Road in the Batford area were developed, as were the West Common and Roundwood localities. By 1927 though, considerable building work had already taken place in Station Road, as can be witnessed in the photograph shot near the junction with Arden Grove. A year later, a new post office was constructed next to Harpenden Dairies, opening for business in September 1928. It is interesting to note today that, while shop fronts alter from time to time, there has been very little architectural change to the facades of the first floors and above.

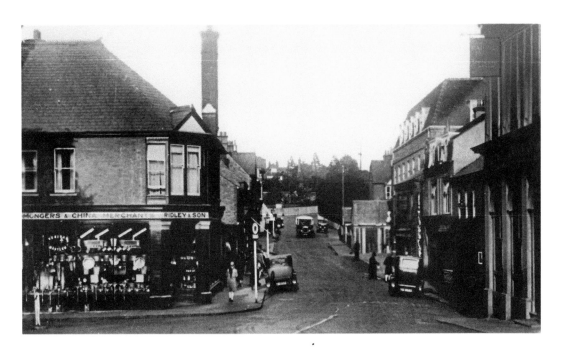

Station Road II

Although the top picture was posted on 12 December 1932, it is highly likely, as with many postcards, that the actual photograph was taken a number of years beforehand. Ridley's the ironmonger was still trading, although closure was to come the following year when the Midland Bank took over the premises. The D. B. Skillman photo below, which was taken from across the High Street in Leyton Road, portrays the right-hand corner of Station Road on which the Railway Hotel was built in 1871, three years after the coming of the railway in 1868. In the early days, there were livery stables attached to the hotel where horses could be hired for the local hunt meet.

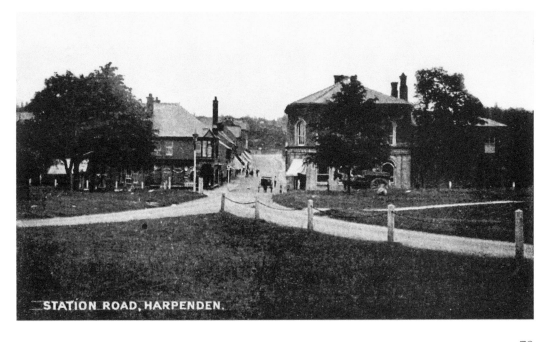

STATION ROAD, HARPENDEN.

CHAPTER 7

AROUND NORTH HARPENDEN AND KINSBOURNE GREEN

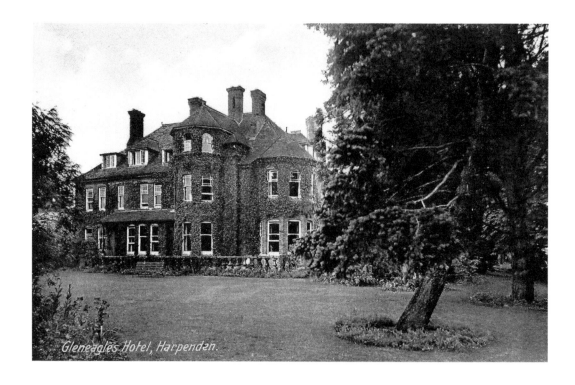

Gleneagles Hotel, Harpenden.

Luton Road

At the northern end of the village centre where the High Street becomes Luton Road and situated on opposing corners of Townsend Lane, were the Kirkwick Hotel and Car Trailers Ltd. The hotel was originally a large nineteenth-century house built in the 1880s for Captain Charles Braithwaite who held several key positions in Harpenden Conservative Club. By 1928, it had become the Kirkwick Hotel, described in an advertisement of the time as a 'charming house standing on gravel soil in 2½ acres of grounds'. The relevance of mentioning the type of ground formation is not known. A further change of ownership took place in 1939 when it was renamed the Glen Eagle Hotel, and by 2008 it was the Glen Eagle Manor Hotel. Today, after extensive alterations, the building is now called Gleneagle Manor, a large complex of luxury apartments. Car Trailers Ltd, as can be seen in their advertising postcard below in the 1930s, offered a tent trailer with either one or two lean-to's that could easily be erected, a brilliant concept that would appear to be way ahead of its time. The site is now occupied by Brayley's, Kia and Mazda motor dealers.

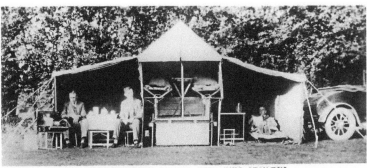

"COUNTY" TENT TRAILER WITH TWO LEAN-TO'S.

"County" Tent Trailer with one lean-to.

Car Trailers' Ltd.,

Harpenden, Herts.

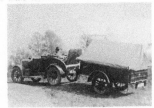

"County" Tent Trailer Lowered for travelling.

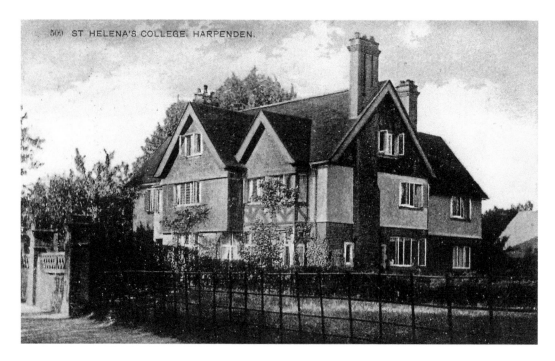

St Helena's College

Built in the late 1890s, St Helena's College was originally a small select school for young ladies of which some were boarders. Sometime after the First World War, the school closed and the building, which had been bought for £3,100 in 1920, became the Harpenden Memorial Nursing Centre in memory of those in the village who had given their lives in the conflict. The two pictures show the front and rear elevations of the college, which today is now called St Helena's Court, a tastefully converted block of flats.

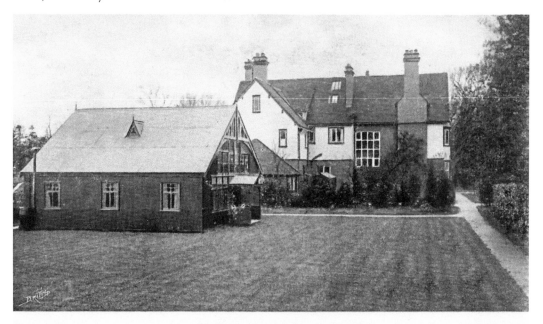

Elliott & Fry, **ST. HELENA'S COLLEGE, HARPENDEN.** London, W.

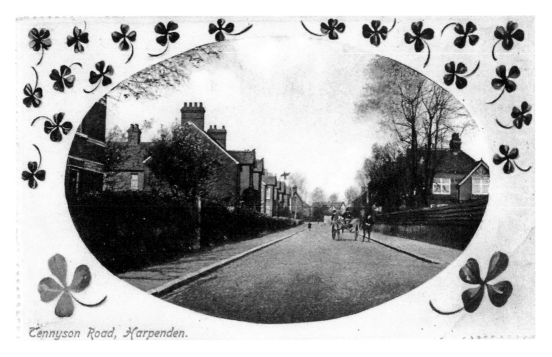

Tennyson Road, Harpenden.

St Hilda's School

An enthusiastic game of basketball by some of the female pupils at St Hilda's School in Douglas Road is in full swing, as pictured below, in this comparatively rare postcard dated 21 April 1911. The school was founded in 1891 by a Miss Craig at a house in Rothamsted Avenue before moving to new premises in Douglas Road sometime around the turn of the nineteenth century. The sender of the card advised the recipient, a scout patrol leader, that 'on Sunday being St George's Day, there is a special service at St John's for scouts at 11. Rector preaching'. This was just four years after the foundation of the scout movement by Lord Baden-Powell. St Hilda's thrives today as an all-girl school. The coloured image shows nearby Tennyson Road, a Victorian thoroughfare built in the 1890s. Like a number of other roads in Harpenden such as Byron, Wordsworth etc., the name reflects a strong poetic association.

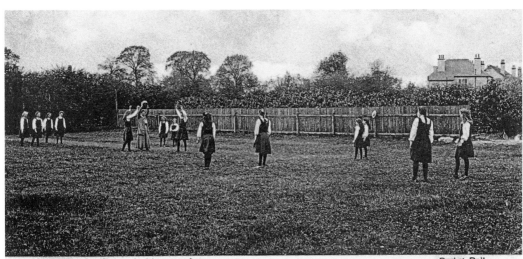

St. Hilda's School, Harpenden Basket Ball

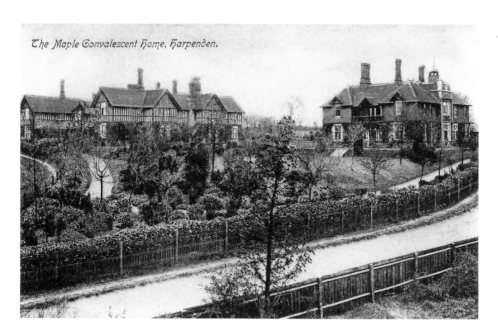

The Maple Convalescent Home, Harpenden.

The Maple Convalescent Home

In 1897, Sir John Blundell Maple MP (1845-1903), a resident of nearby Childwickbury, built the Maple Convalescent Home in Hollybush Lane. Its purpose was to serve as a home where sick employees of his furniture emporium in London's Tottenham Court Road could recuperate until their health had fully recovered. He also commissioned the construction of a group of almshouses called Maple Flats for his retired staff members. In 1929, the convalescent home was transferred to the National Children's Home and named Ackrill House, when it became the residence of retired sisters from the NCH. Ackrill House is now divided into flats. Two early 1900s postcards are featured, with the bottom image posted on 5 September 1907, while unused card above was published by local postmaster and photographer D. B. Skillman.

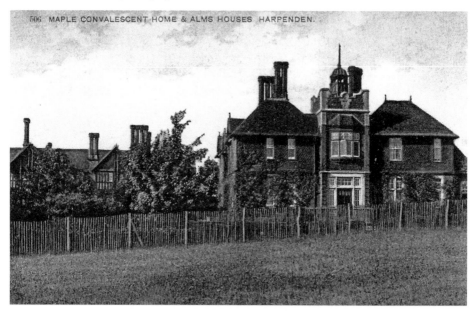

506 MAPLE CONVALESCENT HOME & ALMS HOUSES HARPENDEN.

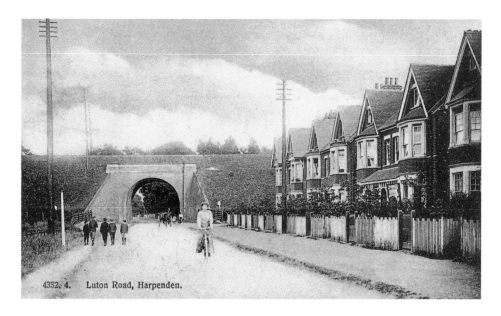

4332. 4. Luton Road, Harpenden.

The Luton Road Railway Bridge

A prominent feature since its construction in 1875, the Luton Road Railway Bridge in north Harpenden, known locally as 'the Arch', is depicted above in this early 1900s postcard. The bridge carried the Harpenden to Hemel Hempstead branch railway, and while the Nickey Line, as it was called, terminated its passenger service in 1947, freight traffic continued over part of the route for several more years until final closure in 1979. During the dark days of the Second World War, the area became a hive of extreme activity during one weekend in November 1942 when a combined exercise that involved the local Home Guard and Civil Defence services was carried out. The object of the manoeuvre was to execute a sustained attack on the bridge, while a group of experienced high-ranking military personnel observed the tactics used. Low-flying bombers from the United States Air Force took part in the operation, adding a touch of realism to the proceedings. Wartime connections along the same stretch of Luton Road can be glimpsed in the bottom picture where two soldiers are seen chatting outside one of the cottages, presumably their billet, while their battalion was based in the village during the early months of the First World War.

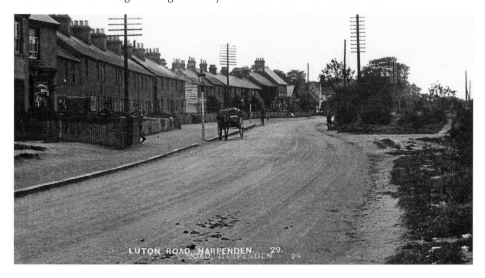

LUTON ROAD, HARPENDEN. 29.

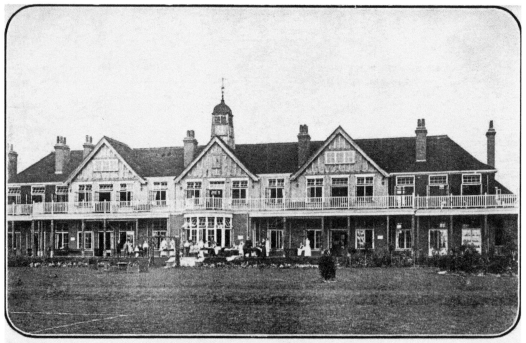

NATIONAL CHILDREN'S HOME AND ORPHANAGE: SANATORIUM FOR CHILDREN THREATENED WITH CONSUMPTION HARPENDEN

National Children's Home Sanatorium

Featured above is the purpose-built sanatorium, part of the National Children's Home, located in Ambrose Lane. It was established in 1910 for children at risk of or suffering from tuberculosis, or consumption as it was then known. With fresh air deemed to aid recovery, the young patients' beds were often wheeled onto the distinctive veranda during the summer months. As soon as improvement started to show, outdoor games were encouraged, as the bottom photograph illustrates, forming part of the process of regaining full health. Today, this beautiful site is occupied by the King's School, an independent Christian school. The images were taken in the 1920s.

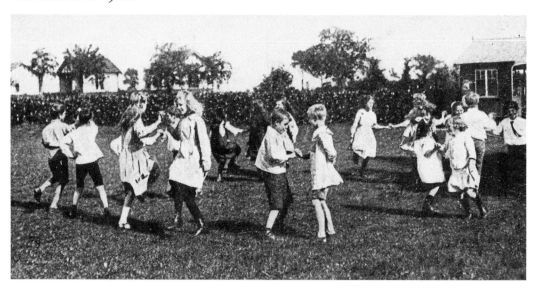

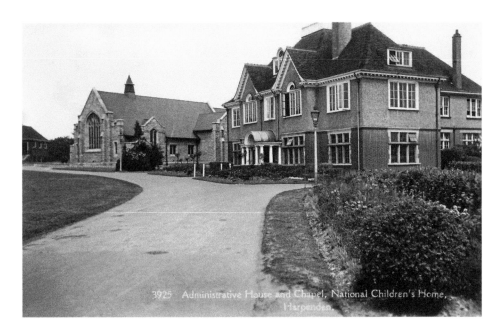

3925 Administrative House and Chapel, National Children's Home, Harpenden

The National Children's Home

Founded in 1869 by Dr Thomas Bowman Stephenson, the National Children's Home catered for boys and girls from broken homes, or where they had been made orphans. Initially, the home was based in a small cottage near Waterloo Station in London, but moved to larger accommodation two years later in Bonner Road, Bethnal Green. In 1913, the home transferred to a lovely 300-acre site in Ambrose Lane, Harpenden and a short distance from the sanatorium. The boys' accommodation was situated on one side of a large grassed area and the girls on the other side. Here, they were educated and on leaving school, the boys were taught in a variety of trades, with apprenticeships offered in the on-site printing school, while the girls could train in secretarial duties such as shorthand and typewriting, or as seamstresses. The two pictures are of the Administration House and Chapel and a rather ambitious-looking gymnastics class.

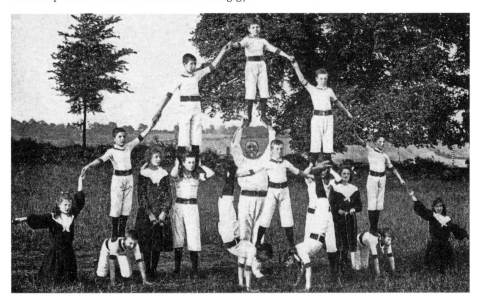

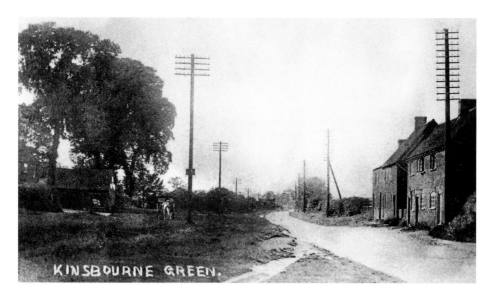

KINSBOURNE GREEN.

Kinsbourne Green

Kinsbourne Green, as illustrated above in this early, somewhat grainy old photograph, was once a small hamlet situated a short distance from Harpenden on a winding, narrow country lane that is now the main A1081 road to Luton. It was here that the kennels for the hounds of the Hertfordshire Hunt were based, until their transfer to Houghton Regis in Bedfordshire during the Second World War. The kennels were then used as an ordnance depot. The two cottages on the right have long since been demolished, while on the left is the Fox public house, once known as the Smyth Arms in 1710 until 1914 when it took on its present name. A popular venue in the 1930s was the nearby Green Lawns, a small country club that attracted an elite and fashionable clientele who would motor out into the country to enjoy afternoon tea, a quiet dinner or an energetic game of tennis. Today, residential housing occupies the club site. Like many small hamlets, Kinsbourne Green once relied on its water supply from the communal village pump as pictured below. Although there had been a well on the site for many years, the hand-operated pump was not installed until 1905 at a cost of £90.

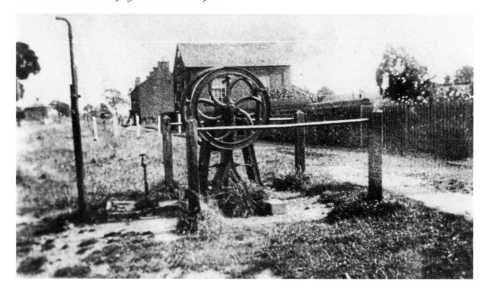

CHAPTER 8
RECOLLECTIONS
OF WARTIME

I SEE YOU'RE BACK FROM THE FRONT!

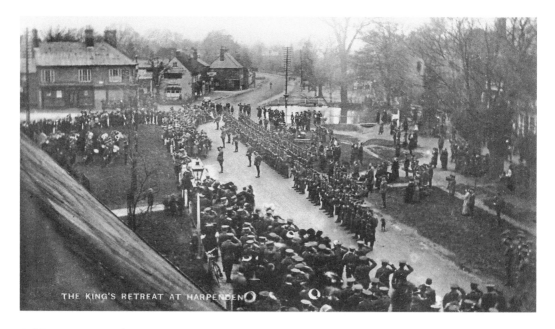

THE KING'S RETREAT AT HARPENDEN

Soldiers in Harpenden

Shortly after the outbreak of the First World War on 4 August 1914, when Germany invaded Belgium leading Britain to declare war on Germany, four battalions of the Notts and Derby Regiments (the Sherwood Foresters) arrived in Harpenden for fitting-out and training exercises before their departure to Essex in November to counter a rumoured threat of invasion. On 25 February 1915, with the German U-Boat campaign around the waters of the British Isles just beginning, the Sherwood Foresters embarked for France. With over 4,000 troops to house and feed around the village, the soldiers were billeted in private homes and other accommodation, while public buildings were requisitioned for administrative purposes and to serve as messes. In January 1915, battalions of the North and South Staffordshire Regiments were stationed in Harpenden, a group of which can be seen below collecting their mail from the Regimental Postman.

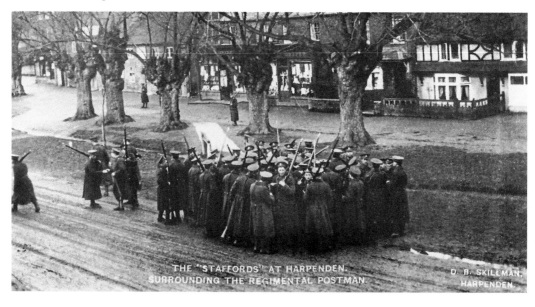

THE "STAFFORDS" AT HARPENDEN.
SURROUNDING THE REGIMENTAL POSTMAN.

D. B. SKILLMAN,
HARPENDEN

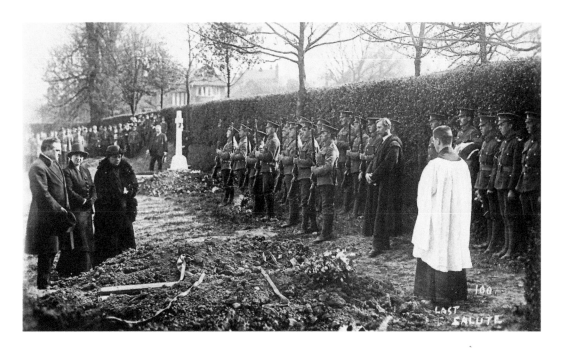

The Last Salute

A cold, grey day in St Nicholas's Churchyard as a young soldier of the North Staffordshire Regiment is laid to rest with full military honours, having succumbed to influenza a few days earlier after a short illness in February 1915. He was just seventeen, having only enlisted in the army two and a half months earlier. The Institute in Wheathampstead Road had been requisitioned early in the war as a military hospital, but as this facility had proved to be too small, Henry Tylston Hodgson of the Welcombe offered his second home, No. 28 Milton Road, to the Senior Commanding Army Officer of the troops, rent free, for use as a more spacious hospital later in 1915.

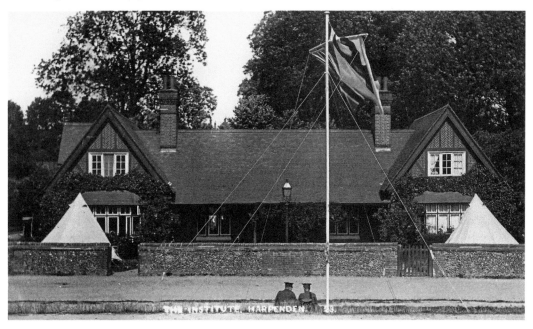

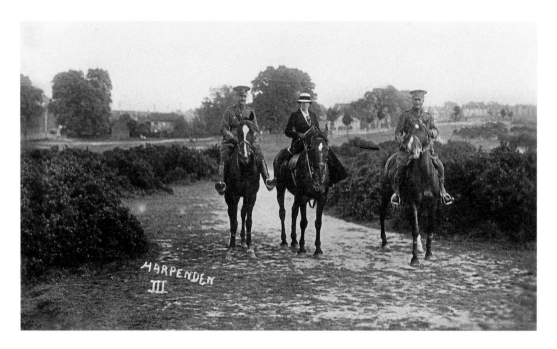

Weapon Training on the Common

On a sunny, late summer's day in 1914, some bemused local residents were able to watch with interest soldiers of the Notts and Derby Regiment carrying out weapon training and fieldcraft on the common in preparation for the conflict ahead. The Silver Cup Pond in the background had been screened off to give the men maximum privacy when taking their daily bathe. Portrayed in the unused postcard above are two officers who appear to be enjoying a quiet off-duty horse ride with a lady companion, who can be seen riding sidesaddle. Just visible in the background is the Queen's Head public house and the Midland Railway in the Bowling Alley.

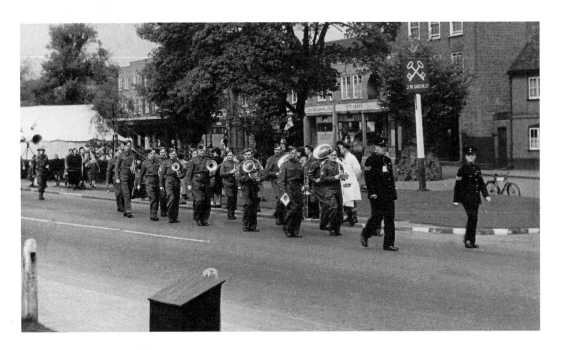

The Home Guard

On 14 May 1940, the government broadcast a message asking for volunteers for the LDV (Local Defence Volunteers). On 23 August 1940, Winston Churchill changed the name to the Home Guard, which was formed when there was a real risk of invasion. Seen in the top photograph is the Harpenden Home Guard participating in the war savings promotion week march in April 1944, just passing the Cross Keys pub in the High Street. These morale-boosting processions were held quite frequently for one purpose or another, similar to the Wings for Victory march below where fighter pilot ace, Wing Commander Frederick 'Bunny' Currant, DSO, DFC and Bar and Croix de Guerre is taking the salute adjacent to the Railway Hotel, now the award-winning pub the Harpenden Arms.

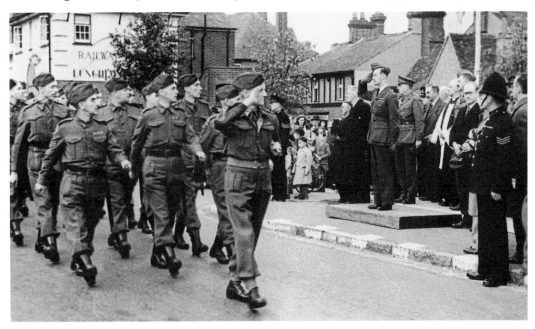

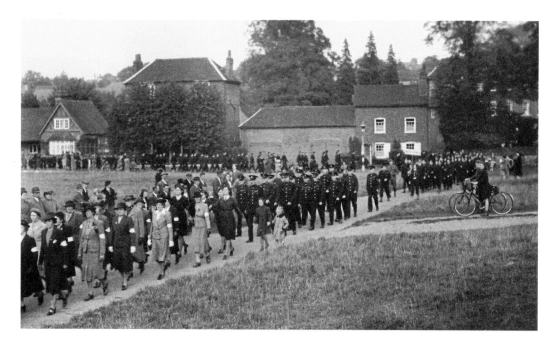

Civil Defence

Another wartime procession is in progress passing the Baa-Lamb trees on the common, this time Battle of Britain Sunday held on 26 September 1943, where various local organisations are participating. In addition to the uniformed groups, including the police and fire service, there would have been representatives from associations such as the WVS (Women's Voluntary Service) who played such an important role in the war effort. Members of the Civil Defence would also have been represented as well. During the Second World War, the area behind Park Hall in Leyton Road was often used for Civil Defence exercises similar to the one illustrated below in August 1942, where a 'bombing casualty' is being tended by some of the wardens.

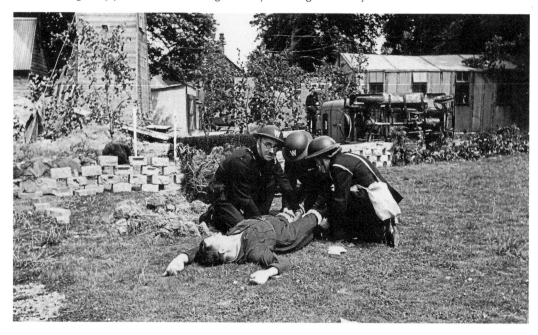

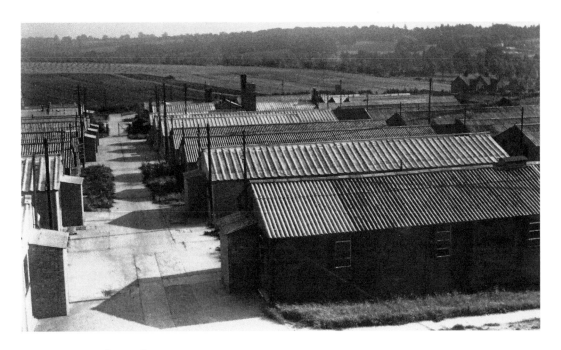

Prisoner of War Camp

In keeping with many other parts of the country during the Second World War, a prisoner-of-war camp was opened locally near Batford in 1943 and held just under 1,000 people. It was located just south of Sauncy Wood on the left-hand side of Common Lane in the direction of Mackerye End. It was originally set up to house Italian prisoners, but from 1944 until just after the war's end German captives were incarcerated there. With the cessation of hostilities in 1945, the prisoners were gradually repatriated, with the camp being completely renovated for civilian accommodation in order to help meet the acute shortage of housing that existed then.

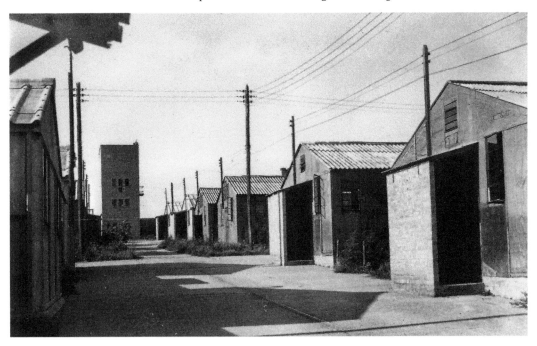

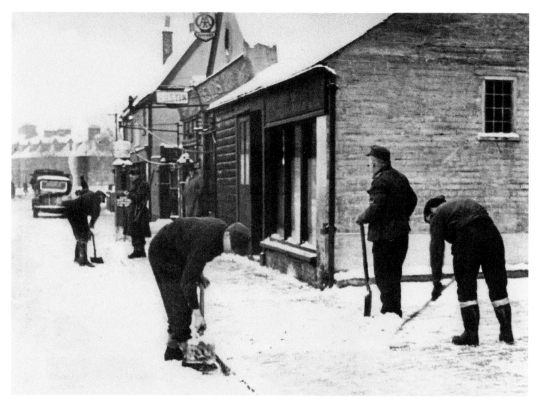

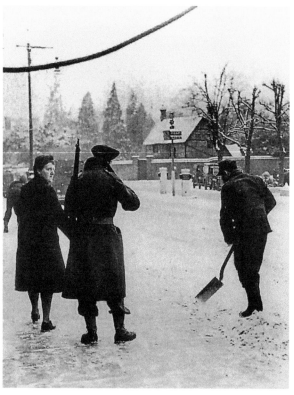

Prisoners of War in Harpenden
With the Second World War drawing to a close in 1945, German prisoners were allowed out of the camp on a daily basis, to either work on the land or to be gainfully occupied in a variety of manual tasks for the local council. During the winter months, lorries brought groups of prisoners to various parts of the village to clear snow and ice from the pavements, as seen in these two images along the High Street and near Sun Lane. This was always under armed guard, although once the war was over there was a tendency for the prisoners to be allowed out on their own. Once the repatriation process commenced, some decided to stay and settle in the area, eventually marrying local girls and integrating themselves into the community. For many of them, it was probably a far better option than if they had returned to their homeland.